TEXAS
OBSCURITIES

TEXAS
OBSCURITIES

STORIES OF THE PECULIAR, EXCEPTIONAL & NEFARIOUS

E.R. BILLS

THE
History
PRESS

Published by The History Press
Charleston, SC 29403
www.historypress.net

Front cover, top right: Antiwar protestors gathered at the base of the Huntington mustangs statue at Texas State University on November 13, 1969. *Courtesy of University Archives, Texas State University*; *middle right*: A Japanese "balloon bomb" airborne. *Courtesy of the National Museum of the United States Air Force*; *bottom right*: "The New Dynamite Balloon." *Harper's Weekly*, May 23, 1885.
Back cover, bottom: *Courtesy of the Texas Collection, Baylor University.*

First published 2013
Second printing 2015

Manufactured in the United States

ISBN 978.1.62619.281.2

Library of Congress Cataloging-in-Publication Data

Bills, E. R.
Texas obscurities : stories of the peculiar, exceptional and nefarious / E.R. Bills.
pages cm
ISBN 978-1-62619-281-2 (pbk.)
1. Texas--History--Anecdotes. 2. Texas--Biography--Anecdotes. 3. Curiosities and
wonders--Texas. I. Title.
F386.6.B55 2013
976.4--dc23
2013040268

For Stacie and my parents

CONTENTS

CONTENTS

INTRODUCTION

There are a million roads in Texas, some paved, some gravel and some dirt. It's difficult to imagine anyone traveling them all in a single lifetime; but it's not hard to envision someone having a working knowledge of most of the roads that connect us to our history, whether it be peculiar, exceptional or nefarious.

This volume is devoted to a number of interesting, compelling and provocative occurrences that transpired on roads now largely forgotten or frequently missed.

SUPREME RESPITE

In 1924, Texas governor Pat Neff had a problem. A case involving fraternal insurance co-op Woodmen of the World reached the Texas Supreme Court, and all three sitting justices were Woodmen. At that time, almost every lawyer and public official in the state was a Woodmen member and a proportionate owner of Woodmen assets and subsequently faced an obvious conflict of interest in the proceedings.

The case, *Johnson v. Darr*, involved two parcels of land valued at $10,000. The tracts were said to have been entrusted to a Woodmen of the World chapter in El Paso by secret verbal agreement. The entrusting party, however, allegedly owed an outstanding debt to the White Mountain Cattle Company. When White Mountain Cattle Company trustees obtained a judgment against the Woodmen of the World's entrusting party for recompense, the Woodmen sued for recovery. In district court, the judiciary seemed to throw their hands up in the air, awarding one parcel to White Mountain Cattle Company and one to the Woodmen. The appellate court later ruled in favor of the Woodmen, awarding them both parcels. Trustees for the White Mountain Cattle Company appealed and were granted a Texas Supreme Court hearing.

On March 8, 1924, Texas Supreme Court justice Calvin Maples Cureton informed Neff that he and the Texas Supreme Court's associate justices,

William Pierson and Thomas Benton Greenwood, were Woodmen and would have to recuse themselves from the proceedings.

For the next ten months, Neff attempted to temporarily replace Cureton, Pierson and Greenwood with qualified male attorneys or judges, but he was unable to find a male candidate outside the Woodmen's scope and reach. In the end, the fraternal co-op's own charter gave Neff an out. The Woodmen of the World expressly forbid the membership of women.

Neff was the first Texas governor to appoint women to the boards of regents of the University of Texas, Texas A&M University and various state teachers' colleges. He was also the first governor to appoint a woman as his chief of staff. There was some question as to whether appointing women to the Texas Supreme Court would even be legal, but when Neff consulted H.L. Clamp, deputy of the Texas Supreme Court from 1902 to 1953, he received a firm "probably" contingent on the candidates in question meeting the basic tribunal requirements of being at least thirty years of age and having practiced law in Texas for a minimum of seven years.

The appointment of one female justice, much less an entire bench of female justices, would be controversial, but on New Year's Day 1925, the Woodmen's incredible purview forced Neff to make history. He created America's first all-female Supreme Court.

The three women chosen to head the special tribunal were Nellie Gray Robertson of Granbury, the county attorney of Hood County; Hortense Sparks Ward, a Houston attorney; and Edith E. Wilmans of Dallas, a former member of the Thirty-eighth Texas Legislature. Robertson was named chief justice, and Ward and Wilmans were designated associate justices.

Unfortunately, however, Neff's nominations were not properly vetted. On January 5, Wilmans announced her resignation because she was two months short of meeting the tribunal's seven-year law practice requirement. Wilmans's resignation was followed by Robertson's; Robertson had practiced law one month less than Wilmans.

The day before *Johnson v. Darr* was slated to convene, Neff appointed Dallas attorney Hattie Leah Henenberg to replace Wilmans and Galveston attorney Ruth Virginia Brazzil to replace Robertson. Ward, by process of attrition, became the tribunal's chief justice.

Chief Justice Ward was already a giant of women's rights in Texas. In 1910, she became the first woman to pass the state bar exam. In 1918, she was the first woman to register to vote in Harris County. Ward was a major player in securing married women's property rights, a leader in the Texas

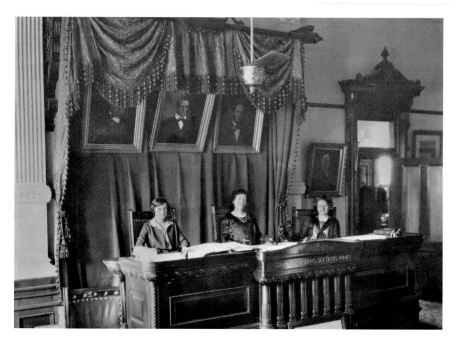

Texas's 1925 all-female Supreme Court was composed of (left to right) Associate Justice Hattie Henenberg, Chief Justice Hortense Ward and Associate Justice Ruth Brazzil. *Courtesy of Texas State Library & Archives Commission.*

suffragist movement and also later the first Texas woman to gain admittance to practice before the U.S. Supreme Court.

Associate Justice Henenberg passed the Texas bar exam in 1916. She worked as a Dallas attorney and was a member of various women's civic and business clubs in the community. And with the assistance of the Dallas Bar Association, Henenberg had also established the Free Legal Aid Bureau for the poor in Dallas because, as she told *Holland's Magazine* later in March 1925, "from birth to death, the poor man is the prey of petty swindlers."

Associate Justice Brazzil passed the state bar in 1912, and her legal career was varied. She practiced mostly in real estate but also worked for a state legislator.

Neff's special Texas Supreme Court met for the first time on January 8 and was heralded as the first "Supreme Court of Women" by the *New York Times*. The court oath, which at the time included a passage requiring petitioners to foreswear that they had never participated in a duel, elicited smiles throughout the courtroom. Recused Supreme Court justice Cureton administered the oath, accompanied by his fellow recused associate justices, and the appeal of the White Mountain Cattle Company trustees was scheduled for late January.

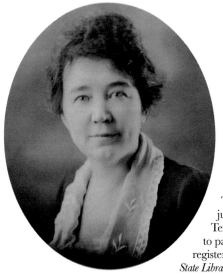

Texas's 1925 all-female Supreme Court chief justice Hortense Ward. Before serving on Texas's highest court, Ward was the first woman to pass the state bar exam and the first woman to register to vote in Harris County. *Courtesy of Texas State Library & Archives Commission.*

Predictably, the historically unchallenged, patriarchal powers that be in Texas grumbled mightily, referring to Ward, Henenberg and Brazzil as the "Petticoat Court." When the special tribunal met on January 30, court clerk Fred Connerly dis-included himself in protest and was replaced. Unmoved, the first female Supreme Court justices in the land heard arguments from attorneys representing the White Mountain Cattle Company and the Woodmen of the World and then recessed to consider the appeal.

On May 25, 1925, the special tribunal reconvened and rendered its decision. At the time, trust agreements—verbal, secret or otherwise—did not have to be recorded to be legally binding. The Woodmen interest prevailed, and Chief Justice Ward authored the majority, unanimous opinion.

Their special bench stint fulfilled, Ward, Henenberg and Brazzil stepped down and went about their careers. When Ward was queried about what was then considered an almost fantastical tenure on the state's highest court, she responded supremely. "The novelty," she said, "is entirely lost in the great responsibility."

At the time of the all-women Supreme Court's decision, Texas women had only been allowed the right to vote for seven years, and though Governor Neff was succeeded by Miriam "Ma" Ferguson as governor—the first female governor in Texas history—it would be three decades before women won the right to serve on juries and almost six before another woman was appointed to the Texas Supreme Court.

PROJECT X-RAY

When the Japanese bombed Pearl Harbor on December 7, 1941, a Pennsylvanian dental surgeon named Lytle S. Adams was visiting Carlsbad Caverns in New Mexico. Adams was disturbed by the news, but his amazement at the millions of bats that emerged from the caverns every night and then returned before every dawn gave him an idea. He wondered if they could be fitted with incendiary devices and dropped from planes. Many of the buildings in Japanese cities were constructed of wood, and if bats could be weaponized, it would simply be a matter of releasing them to roost before sun-up, at which time built-in timers could ignite the incendiaries, creating thousands of fires simultaneously.

On January 12, 1942, Adams communicated his thoughts to the White House by letter. Adams's idea made it to President Franklin Delano Roosevelt's desk, and within days, Roosevelt had dispatched instructions regarding the plan to an army colonel. "This man is not a nut," Roosevelt wrote. "It sounds like a perfectly wild idea but is worth looking into."

The "bat-bomb" project was soon off the ground, and the effort appeared promising. Bats generally appeared in large numbers, could carry twice their own weight in flight, could fly in darkness, would roost in secluded places (usually avoiding detection) and, perhaps most importantly, could be manipulated to hibernate. While dormant, they required no food or maintenance.

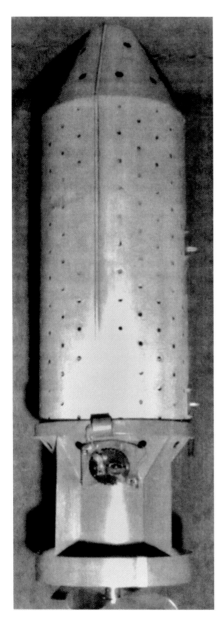

The "bat-bomb" canister was packed with cardboard cartons that housed the actual bombers: Mexican Free-Tailed Bats. *Courtesy of the United States Army Air Forces.*

Adams himself was recruited to research and choose a suitable species and acquire sufficient numbers of bats. By March 1943, the Mexican Free-Tail Bat had been chosen for the operation and future military napalm inventor Louis Fieser was designing miniature incendiary devices for the "bombers." The bats were being collected from the Devil's Sinkhole and the Bracken and Ney caves in Texas and Carlsbad Caverns in New Mexico

In mid-spring 1943, 3,500 bats were used in tests at Muroc Dry Lake in California. First they were placed in refrigerators and forced to hibernate. Then, on May 21, 1943, a test run involving five large canisters of bats was executed. The bats were dropped from five thousand feet and descended too quickly; they never took wing because they had not fully recovered from hibernation.

The project was relocated to a new auxiliary airfield under construction at Carlsbad, New Mexico, and the experiments continued. In the next test run, the bats were placed in ice cube trays to facilitate hibernation and then fitted with dummy incendiaries and positioned in cardboard cartons for the drops. Unfortunately, when the next batch of bats descended from bombs dropped from a B-25 and a Piper L-4 Cub, many, again, didn't recover from hibernation quickly enough. Also, some of the cardboard cartons failed to open properly, and many of the dummy incendiary devices fell free of the bats.

In one live incendiary exercise in 1943, several of the bats brought literal meaning to the phrase "friendly fire." They roosted in official Carlsbad Airfield buildings and inadvertently set them ablaze. *Courtesy of the United States Army Air Forces.*

Team members gathered more Mexican Free-Tailed Bats and tried again. This time, they allowed the bats more time to recover from hibernation before they were deployed, but after being fitted with dummy devices, many woke up too quickly and escaped from the cardboard cartons.

Testing continued with mixed results. By early June, the Mexican Free-Tailed "bombers" were performing live practice runs and had inadvertently burned down the new Carlsbad Airfield's control tower, a barracks and several other buildings, all while in various stages of construction. A report dated June 8, 1943, indicated that work on the project had concluded until researchers developed better incendiary device attachment mechanisms, a special time-delay, parachute-delivered bat container (to allow the "bombers" more time to shake of the effects of hibernation) and a less complicated time-delay igniter to activate the incendiary payloads.

In August 1943, the project was passed on to the navy and assigned to the marine corps. The marines renamed the effort Project X-Ray and began guarding the Devil's Sinkhole and the Bracken and Ney caves around the clock. The experiments recommenced at the Marine Corps Air Station in El Centro, California, on December 13 utilizing improved egg crate bat trays

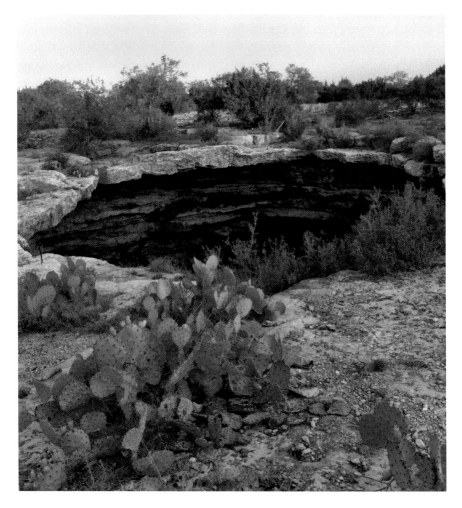

The Devil's Sinkhole, located just outside Rock Springs, was home to a secret weapon during World War II. *Photo by Catie Jones.*

in the bomb canisters. After numerous experiments and operational tweaks, a definitive test mission was executed over a mock-up Japanese village at the Dugway Proving Grounds test site in Utah.

An incendiary specialist at Dugway reported that the bat "bombers" were effective because the small units were capable of creating a reasonable number of destructive fires without being detected. A National Defense Research Committee observer concurred, concluding that Project X-Ray had indeed produced an effective weapon.

After some positive results and optimistic accounts, more advanced and effective incendiary devices were ordered, and an expanded Project X-Ray test run regimen was scheduled for August 1944. But by then, Project X-Ray was racing against the Manhattan Project, and when Navy Fleet admiral Ernest J. King was informed that the bat bombers would probably not be combat ready until mid-1945, he canceled the project.

Texas's Mexican Free-Tailed Bats lost out to the atom bomb. The marines quit guarding the bat caves, and the bats' strange conscription was over.

SLOCUM MASSACRE

G enerally speaking, the Texas State Historical Association's Handbook
of Texas Online is a good place to start for cursory research on most
Texas events, issues and towns. Exceptions usually involve controversies, and
Slocum, Texas, ranks among the most conspicuous.

The current Texas State Historical Association Handbook blurb on
Slocum mentions how the community got its name and its first post office
in 1898 and then skips to 1914, when it notes that the town had two general
stores and approximately forty-five residents. What the blurb doesn't tell you
is that Slocum had a major population reduction in 1910.

Unlike most Texas communities in the early twentieth century, the
unincorporated town of Slocum was mostly African American. Several
black citizens were considerably propertied, and a few owned stores and
other businesses. This alone, in parts of the South, was enough to foment
violence. But in the Slocum area, there were other issues.

When a white man reportedly tried to collect a debt from a well-regarded
black citizen, there was a dispute and hard feelings lingered. When a regional
road construction foreman put an African American in charge of some local
road improvements, Jim Spurger, a prominent white citizen, was infuriated.
Spurger became an agitator, and rumors began to spread. Gossip in white
circles warned of African American threats against white citizens and plans for
race riots. Racist malcontents worked the local Anglo population into a frenzy,

TEXAS OBSCURITIES

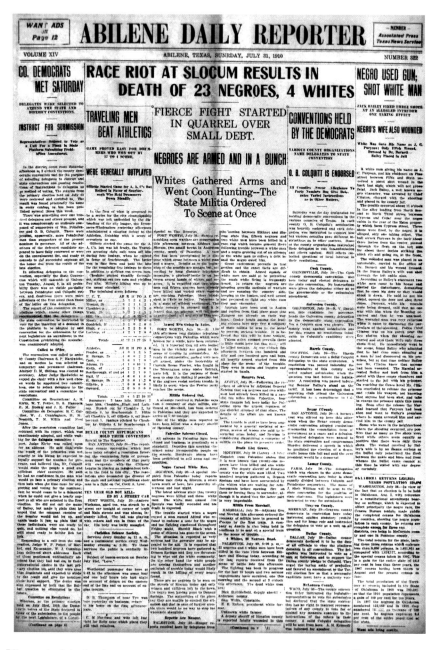

Like most of the local, state and national newspapers that reported on the Slocum
Massacre, the *Abilene Daily Reporter* mistakenly characterized the affair as a race riot
instigated by trouble-making "negroes." Unlike most local, state and national publications,
however, the *Reporter* blatantly conveyed its bias with the first phrase of its final subhead:
"Whites Gathered Arms and Went Coon Hunting." *Courtesy of Abilene Public Library.*

and on July 29, white hysteria transmogrified into bloodshed. Hundreds of Anglo citizens from all over Anderson County converged on Slocum armed with pistols, shotguns and rifles. That morning, near Saddlers Creek, they fired on three African Americans headed to feed their cattle, killing eighteen-year-old Cleveland Larkin and wounding fifteen-year-old Charlie Wilson. The third, fifteen-year-old Willustus "Lusk" Holley, escaped only to be shot at again later in the day while he, his twenty-three-year-old brother Alex and their friend William Foreman were fleeing to Palestine. Alex was killed and Lusk was wounded. Foreman fled and disappeared. Lusk pretended to be dead so a group of twenty white men would not finish him off.

White mobs marched through the area shooting blacks at will. A thirty-year-old African American named John Hays was found dead in a roadway, and twenty-eight-year-old Sam Baker was shot to death at his house. When three of the Bakers' relatives (Dick Wilson, Jeff Wilson and a seventy-year-old man named Ben Dancer) attempted to sit up with his body the following night, they, too, were gunned down in cold blood.

In addition to the murders in the southern Slocum area of Anderson County, Will Burley was killed near the northern edge of Houston County.

Every initial newspaper story on the transpiring bloodshed portrayed the African Americans as armed instigators, but the reporting was grossly inaccurate. When district judges in Palestine closed saloons and ordered local gun and ammunition stores to stop selling their wares on July 30, it was not to quell a black uprising; it was to defuse what the *Galveston Daily News* called an indescribable one-sided "reign of terror" that resulted in numerous bullet-ridden African American corpses strewn along scattered, "lonesome roads."

When reporters gathered on July 31, up to two dozen murders had been reported, but local authorities only had eight bodies. Once the carnage had begun, hundreds of African Americans ran to the surrounding piney woods and local marshes. By the time the Texas Rangers and state militia arrived, there was no way to estimate the number of African Americans dead.

On August 1, a few Texas Rangers and other white men gathered up six of the African American bodies and buried them (wrapped in blankets and placed in a single large box) in a pit four miles south of Slocum. Farther north, Marsh Holley, father of Alex and Lusk, was found on a road just outside Palestine. He asked the authorities in Palestine for help, requesting that he be locked up in jail for protection. Marsh—whose family owned a store, a dairy and several hundred acres of farmland—identified himself as the black citizen involved in the debt dispute but denied that the affair ever grew into a serious provocation.

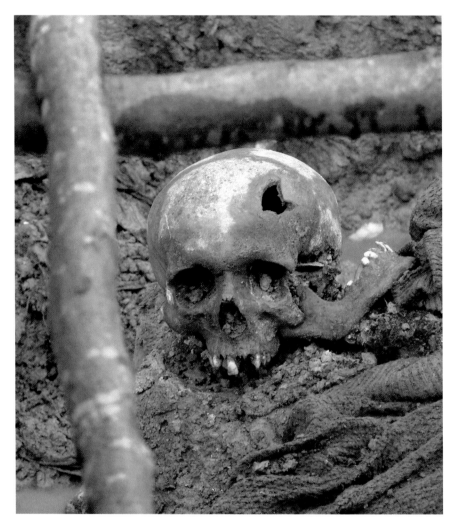

The unearthed skull of a victim of the 1995 Srebrenica massacre in Bosnia. If a full and thorough investigation of the Slocum Massacre is ever conducted, the earth in southern Anderson County will likely yield similar finds. *Photo by Adam Jones, adamjones.freeservers.com.*

After the first several murders, much of the African American community began leaving, but this didn't stop the white mobs. They shot blacks in the back, even if they were clearing out. Two bodies found near the town of Priscilla still had travel bundles of food and clothing at their sides.

From the outset, Anderson County sheriff William H. Black said it would be "difficult to find out just how many were killed" because they were "scattered

all over the woods." He also admitted that buzzards would find many of the victims first, if at all. And it's reasonable to suspect that after the initial bloodlust had subsided, some transgressors returned to the crime scenes to remove evidence of the murders. Certainly with the arrival of the press—after early attempts at spinning the reports to portray the African American victims as violent insurrectionists had failed—the guilty Anglo contingents engaged in damage control efforts. But Sheriff Black was inexorable.

"Men were going about killing Negroes as fast as they could find them," Black told the *New York Times*. "And, so far as I was able to ascertain, without any real cause."

"These Negroes have done no wrong that I can discover," Black continued. "I don't know how many [whites] were in the mob, but there may have been 200 or 300. Some of them cut telephone wires. They hunted the Negroes down like sheep."

According to the local law enforcement leaders on hand at the time, eight casualties was a ludicrously conservative number. Sheriff Black and others insisted there were at least a dozen more, and some reports suggest there may have been dozens more. Frank Austin, the president of the First State Bank of Frankston, reported the death of an African American named Anderson Austin near Slocum, but it was never investigated. Abe Wilson—whom Houston County justice of the peace Pence Singletary identified as the African American who had been put in charge of the local road improvements—disappeared and was never heard from again. A reliable fatality count was impossible, especially with the perpetrators likely covering their tracks. And the deceased weren't the only folks becoming scarce; surviving African Americans began to disappear as well.

It was one thing to return to your home or your daily routine after the odd murder or infrequent lynching of a friend, neighbor or relative—black folks in the South were not unused to that. But a localized campaign of genocide, where the executioners surrounded you and cut phone lines to prevent you from getting help? That was not something Slocum-area African Americans could easily relegate to a list of bygones. And with a large contingent of the black community running for their lives, several victims went unidentified and many disappearances were unreported. The arrival of the Texas Rangers and the state militia simply made it safe enough for the remaining African Americans to pack their belongings and leave without being shot at.

In the weeks and months following what came to be known as the Slocum Massacre, the African American population made a mass exodus, leaving homes, properties and personal connections to the land and the community.

At the initial grand jury hearing, nearly every remaining Slocum resident was subpoenaed; some residents refused to testify and were arrested. The grand jury judge, B.H. Gardner, of Palestine, told the all-male, all-white jury that the massacre was "a disgrace, not only to the county, but to the state," and it was up to them to do their "full duty."

According to the August 2 edition of the *Palestine Daily Herald*, Judge Gardner said that even if there had been threats or conspiracies "on the part of any number of Negroes to do violence to white persons, it would not justify anybody to take the law into their own hands.

"The law furnishes ample remedy," Gardner continued. "There is no justification for shooting men in the back, waylaying or killing them in their houses."

By the time the grand jury findings were reported on August 17, several hundred witnesses had been examined. Though eleven men were initially arrested, seven were indicted—and they were only accused in the murders of five of the identified victims. Defendants Reagon McKenzie, T.W. Bailey and Morgan Henry were released without being charged. Jim Spurger was indicted in two cases, B.J. Jenkins in four cases and Curtis Spurger, Steve Jenkins, Isom Garner and Andrew Kirkwood in three cases. The seventh indicted man was not arrested or named; only Kirkwood was immediately granted bail. No charges were filed for the killings of John Hays, Alex Holley or Anderson Austin or the disappearances of Abe Wilson, William Foreman and others.

After the grand jury indictments came down, Judge Gardner decided to move the trial to Harris County, distrusting the potential jury of peers the defendants might receive in Anderson County. The indictments received no interest or justice in Harris County.

On May 4, 1911, Palestine judge Ned B. Morris petitioned the Travis County Court of Criminal Appeals to grant bail for the remaining defendants, and it was granted. Eventually, all those charged were released, and none of the indictments was ever prosecuted.

In the meantime, the personal holdings of many Slocum-area Anglo citizens—the folks who perpetrated the massacre as active participants or passive bystanders—substantially increased. The abandoned African American properties were absorbed or repurposed as the now majority white population saw fit. The standard southern Anglo-centric world order was restored, and this order endures to the present day.

According to recent demographic statistics, most of the communities around Slocum have significant African American populations that average

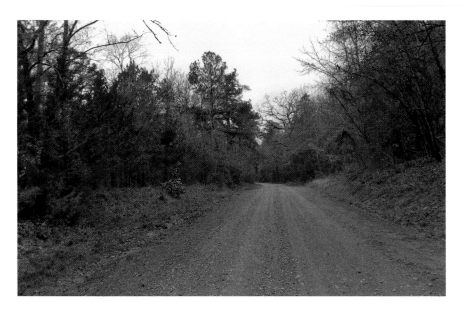

A Slocum community back road. It and others wind through lands where untold numbers of Slocum-area African Americans ran for their lives and unacknowledged numbers were slaughtered and buried in unmarked graves. *Photo by author.*

around 28 percent. Grapeland's is 35 percent, Rusk's is 30 percent and Palestine's and Alto's are 25 percent. Slocum's African American population is just under 7 percent.

On April 24, 1929, a tornado rolled through Slocum, leveling the town and killing seven people, and organizations from all over East Texas raised money for the town's recovery. Though the Slocum Massacre's casualties were greater and its African American community's coerced migration was arguably just as landscape-altering, the twister overshadowed the localized genocide of 1910, and the event is largely forgotten—or conspicuously ignored—today.

There have been no official or unofficial investigations to determine the extent of the carnage or number of actual victims of the Slocum Massacre. According to contemporary headlines, law enforcement officials and present-day oral histories passed down by descendants of massacre victims, scores of African Americans may have lost their lives in the Slocum Massacre—not eight or merely twenty-two. The bloodshed was greater than that of Oklahoma's Tulsa Riots of 1921 and Florida's Rosewood Massacre of 1923.

On March 30, 2011, after a February 27 story on the Slocum Massacre in the *Fort Worth Star Telegram* (by Tim Madigan), the Eighty-second Texas

Legislature adopted House of Representatives Resolution 865 (filed by Representatives Marc Veasey and Lon Burnam), acknowledging the massacre of 1910. It admitted that a white mob went on a "bloody rampage" that resulted in at least eight deaths (and probably more) and a forced African American migration. The resolution concluded with platitudes, stating that "only by shining a light on previous injustices can we learn from them and move forward," but the little-publicized gesture hardly aids in education or progress in Slocum or Anderson County.

In testimony presented at the bail hearing on May 10, 1911, Slocum-area defense witness Alvin Oliver criticized the "insolent manner and conduct" of the local African American population during the period preceding the massacre and brazenly noted that things were different after the bloodshed. "The Negroes down there are not disbehaving now," Oliver observed.

And he was right.

There were hardly any left.

LONE STAR LINDY

In 1923, Charles Lindbergh was not a world-renowned aviator or international celebrity. In his first trip to Texas, he piloted a run-down, 1917 World War I surplus Curtiss JN-4D biplane to Texarkana and whimsically touched down just long enough to say he'd been here. A year later, with approximately 250 hours of recorded flight time, he submitted an application to attend advanced flight school at the army's Brooks Field Air Base in San Antonio. While awaiting word in Missouri, a friend named Leon Klink invited him on an air tour of the Deep South.

Klink, a St. Louis car dealer, had purchased a yellow World War I surplus Curtiss JN-4C biplane. It was a ninety-horsepower single-engine that barely topped out at seventy-five miles per hour. Klink wanted Lindbergh to take it for a spin through the Gulf states, teaching him how to fly as they went. Lindbergh accepted.

Lindbergh and Klink left St. Louis on January 24. They flew through Kentucky, Tennessee and Florida, taking pause in Pensacola after an engine failure over the ocean grounded them for repairs. While there, Lindbergh learned that he'd been accepted into the army's flight program and that he was expected to report on March 15. Since that was a month and a half away, Lindbergh and Klink decided to make a trip to California, tracing the route of the Southern Pacific Railroad.

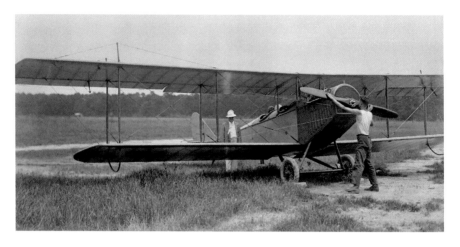

Charles Lindbergh made his 1924 excursion through Texas in a ninety-horsepower, single-engine World War I surplus Curtiss JN-4C Canuck biplane that topped out at seventy-five miles per hour. *Courtesy of United States Library of Congress.*

After flying over Louisiana and crossing into Texas, they got lost. Lindbergh misread his map, and they mistook the Uvalde and Northern Railroad along the Nueces River for the Southern Pacific Railroad along the Rio Grande. When the tracks of the Uvalde and Northern Railroad ended at an unmapped logging town, Lindbergh realized his mistake, but they were running low on fuel. Lindbergh decided to put the Canuck down in a plowed field near Camp Wood.

Once on the ground, Lindbergh and Klink hitched a ride into town to buy fuel. By the time they got back to the plane, it was late, and some local ranch owners (the Chant family) offered them accommodations for the night.

The following morning, they returned to the Canuck and had problems getting into the air. The plowed field was not long enough for the fully loaded craft to take off in. Klink climbed out, taking their luggage, the toolbox and the passenger seat with him. If Lindbergh could get the lightened Canuck off the ground, he would meet Klink at Camp Wood and they would re-try their ascent on Uvalde Road, the town's main street.

Lindbergh got the Canuck into the air and landed on Uvalde Road. When Klink arrived, they loaded the plane and got ready to depart. Uvalde Road had two telephone poles and a line strung between them across the thoroughfare. The telephone poles were forty-six feet apart, and the Canuck's wingspan was forty-three feet. There wasn't much margin for error, but Lindbergh was confident he could squeeze through.

When the Canuck lurched forward for takeoff, everyone in Camp Wood (and half of Real County) had gathered along Uvalde Road to watch Lindbergh and Klink's departure. There farewell pass turned out to be more Charlie Chaplin than Charles Lindbergh.

As the craft picked up speed, a wheel hit a rut, the Canuck veered and one pair of wings clipped a telephone pole. Lindbergh lost control, and the plane crashed into a hardware store owned by Warren Pruett. The hardware establishment was unoccupied when the Canuck broadsided it, and Lindbergh and Klink emerged from the wreckage unscathed. The plane's fuselage and wooden propeller were damaged, and its radiator was smoking. In additional Chaplin fashion, the collision scattered pots and pans across the store's hardwood floor, and a portrait of President Calvin Coolidge reportedly started and jumped and then joined the strewn cookware on the hardwood.

Assisted by several Camp Wood citizens, the unlucky aviators maneuvered the damaged Canuck over to a local repair garage owned by Ben Wall and Russell Vernor. They serviced the radiator but couldn't level the damaged propeller or patch the torn fuselage. Lindbergh and Klink ordered a new propeller and patching shellac from Houston and then waited.

They let a room at the Fitzgerald Hotel and passed the time with Camp Wood locals. Mr. Pruett told Lindbergh not to worry about the damage to his hardware store, commenting that folks would come from miles around to see where the brave young aviators had escaped death.

When the new propeller and patching compound arrived a few days later, Lindbergh and Klink performed the necessary maintenance and then gave the locals five-dollar plane rides to mitigate their unforeseen expenses.

Their final Camp Wood departure was not at all Chaplin-esque, and in no time, they were once again tracing the Southern Pacific Railroad toward California. Eventually, they crossed the Rio Grande and flew over a span of Mexico. When they recrossed the Rio Grande, they landed in a small army airfield near Pumpville (seventeen miles northwest of Langtry) and talked the attending officer into selling them enough fuel to continue westward.

Lindbergh and Klink began to lose light shortly after they crossed the Brewster County line and landed next to a smattering of railroad structures near Maxon Creek (eighteen miles south of Sanderson and just north of Hell's Half Acre, a patch of rugged topography characterized by shallow soils and stony clay). There, they discovered a railroad section boss living alone, waiting to be relieved. They spent the night with him in the section house and began scouting a takeoff path the next morning.

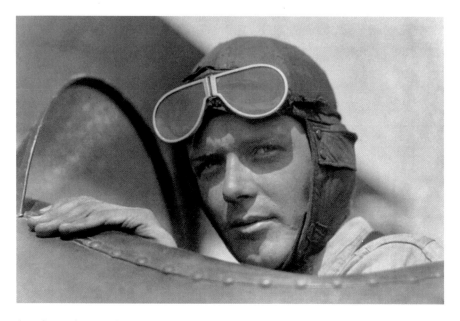

American aviator, author, inventor and explorer Charles Lindbergh was the first person to make a transatlantic crossing by air, leaving Roosevelt Field in Garden City, New York, on May 20, 1927, and landing at Le Bourget Field in Paris, France, thirty-three hours, thirty minutes and 29.8 seconds later. Before he was an international celebrity, he was a barnstormer who enjoyed an eventful jaunt through Texas in 1924. *Courtesy of the United States Library of Congress.*

Daylight revealed an inhospitable landscape littered with sagebrush and cactus. It was a wonder the plane hadn't been damaged during the landing. Lindbergh and Klink spent the whole morning and early afternoon clearing a runway.

By the time the Canuck reached the end of the makeshift runway, it was only a few feet off the ground, and the top of a Spanish Dagger plant passed through part of the lower left wing. Lindbergh landed immediately. Luckily, an engineer on a passing freight train witnessed their mishap and stopped the train long enough for Klink to climb aboard. Klink departed in search of repair supplies at the nearest locale. Lindbergh stayed behind with the Canuck.

The section boss left for a new location, and Lindbergh walked to a nearby ranch house in search of accommodations. The owner of the ranch agreed to put up Lindbergh, and when he wasn't Canuck-sitting, Lindbergh explored the ranch and joined the rancher and his hounds on panther and mountain lion hunts.

Klink traveled all the way to El Paso for the repair supplies and then returned the way he came. By the time Lindbergh and Klink got the Canuck airworthy again, it was approaching mid-March, and Lindbergh was due at Brooks Field. They doubled back to San Antonio, and Klink continued to California by train.

Lindbergh's stint at flight school was exceptional, but it did include more hair-raising ups and downs. After narrowly parachuting to safety following a midair collision during training maneuvers on March 6, 1925, Lindbergh went on to graduate at the top of his Brooks Field Air Cadet Class. On May 21, 1927, he became an aviation icon when he piloted the Spirit of St. Louis on the world's first nonstop transatlantic flight from New York to Paris.

Later in the decade, he returned to the state where he'd honed his flight skills, surveying the first commercial transcontinental air route through the Panhandle in 1927 and inaugurating the original U.S.-Mexico airmail service in Brownsville in 1929.

Today, Lindbergh has a park named after him in Camp Wood, and Klink a street. In 1977, an eighty-three-year-old Klink returned to Texas and Camp Wood for the fiftieth anniversary of Lindbergh's transatlantic crossing. Lindbergh had passed away three years earlier.

SATAN'S STORM

Wednesday, June 14, 1960, was like most other summer days in Kopperl, Texas. The temperature was mild in the early and late morning and began marching toward the century mark as the afternoon went on. Didn't make it, but got close—and then the temperature retreated steadily to the mid-seventies as nightfall set in. A light breeze lingered, teasing a wind chime or two, and a million crickets chirped in the background. Flashes of lightning had threatened earlier, but nothing had come of them. By 10:00 p.m., most folks were already in bed or on their way.

Just after midnight, however, conditions changed rapidly. A torrid wind blew through at speeds of eighty to one hundred miles per hour, and the temperature doubled. The roofs of a local grocery and nearby barns flew away. Trees toppled, and power poles snapped. Several passing automobiles overheated and broke down.

When the power failed, air conditioners (many of them swamp coolers) died, and the citizens of Kopperl woke to houses that had become furnaces. Some folks ran outside, thinking their homes were on fire, but when they opened their front doors, the oppressive heat hit them like a hurricane gale and they found it hard to breathe.

Families hosed themselves down and took refuge in cellars and storm shelters. Mothers wrapped their children in wet towels and sheets to protect

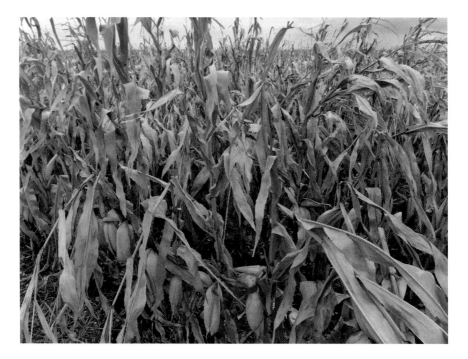

When the Kopperl heat burst struck in the wee hours of June 15, 1960, the temperature in the town increased to 140 degrees Fahrenheit. Acres of cotton were carbonized, and cornfields were scorched and wilted. *Photo by author.*

them from the sudden swelter. For almost three hours, the fierce winds and suffocating heat laid siege to the community, and many folks thought the end was nigh.

And then it was over.

The event dissipated as quickly as it had come.

The citizens of Kopperl were startled but relieved. They took quick stock of any damage to their property and then tried to snatch what little hours of sleep they could before daylight.

The following morning was as stark as the night was scary. A large cotton patch that had been plowed the day before was now carbonized. Multiple corn fields around the town—green twenty-four hours prior—were now scorched and wilted.

An outdoor thermometer located at a Kopperl bait shop had jumped from 70 degrees to 100 degrees in a matter of moments around midnight and then climbed to 140 degrees during the turmoil. The next day, it was working fine.

Veteran KXAS photographer Floyd Bright was sent out to investigate what was preliminarily (and mistakenly) considered a tornado touchdown in the town. He came away saying it was "the most unusual weather story" he had ever covered.

In the early 1970s, famed Fort Worth meteorologist Harold Taft researched the event and published his findings in a 1975 book (co-authored by KXAS Staff Meteorologist Ron Godbey), *Texas Weather*. In a chapter entitled "The Strangest Storm in Texas or the Night the World Almost Came to an End in Kopperl," Taft stated that in the waning moments of June 14, thunderstorm rain shafts had been detected over Kopperl on Fort Worth radar but then suddenly vanished. The downward draft that would have carried cooling moisture in the form of rain down the thunderstorm shafts continued on without rain and without a moisture coolant. Essentially, the downward drafts of the dried-up thunderstorm heated as they descended and compressed and blasted Kopperl like a massive blow-dryer.

At the time, retired school superintendent George Day claimed that the freak event reminded him "of what hell might be like." Local farmer Pete Burns concurred, insisting it had been so hot he couldn't place his hands on the walls of his house. "I thought, well, there will be a guy along shortly with a pitchfork to pick us up," Burns said. "It was just like being in an oven."

Today, the phenomenon that Day and Burns and the rest of Kopperl endured is known as a heat burst and is not altogether uncommon. But the Kopperl instance is still acknowledged as one of the worst heat bursts on record, and folks there still refer to it as "Satan's Storm."

TEXAS UTOPIA

Initially, John B. Christensen's idea was wildly fortuitous. Procure a large parcel of land and start a colony based on hard work and self-sufficiency. With "little to buy and much to sell," prosper and grow and repeat as necessary.

Christensen started the colony on January 1, 1929, and by the time the stock market crashed eleven months later, his experiment, called Kristenstad (based on his family name as it was spelled in Denmark), was almost entirely unaffected. Exactly none of the residents in Kristenstad found themselves unemployed, poor or landless. Some newspapers around the country hailed Kristenstad as the cure; others said that it was a shame that in a nation like the United States, a community with no electricity, gas or piped water stood out as a beacon of progress or security.

Born in Missouri to Danish immigrants in 1874, Christensen studied law at the University of Missouri and graduated at the top of his class in 1895. He began practicing law in Missouri and then became an attorney for a railroad company in the southwest part of the state. In 1914, he moved to Dallas, Texas, and became a railroad entrepreneur. He partnered up and began buying and reorganizing short-line railroads.

In the mid-1920s, Christensen moved to Glen Rose and took an interest in a nearby Scandinavian settlement. He was inspired by their ingenuity

and meticulously cultivated plots of land. The successful Scandinavian community was resourceful and self-supporting, and Christensen dreamed of applying these principles on a larger scale.

Christensen researched the notion and began keeping an eye out for the right piece of property. He contacted other Danish families about the idea, and his plans were well received.

In 1928, he found an excellent location in Hood County, near Granbury. He purchased a six-thousand-acre tract located in what was known as De Cordova Bend. Practically an island, De Cordova Bend was virtually enclosed by the Brazos River and had nineteen miles of riverfront. The land in the Bend itself was of sufficient elevation to guard against flooding and featured a large natural spring in its interior. A rugged patch called the "Narrows" connected it to the "mainland," but Christensen had it on good information that the Brazos River Conservation and Reclamation Project would soon be placing a dam in the Bend, and that would mean a new road into Kristenstad.

After a careful screening process, the colony was started with thirty families, a dozen of whom were of Danish descent. Acreage in the Bend was purchased for forty dollars an acre on twenty-year notes.

The residents of Kristenstad immediately got to work. They built pleasant, durable houses with their own hands, utilizing native lumber and stone and purchasing only nails, glass and roofing materials from outside the colony. They constructed a sawmill and took the trees they felled to the sawmill to have them converted into lumber.

Aware that approximately 60 percent of each tree they felled and converted to lumber would be wasted byproduct, they also built a wood-carving shop that produced chairs and a charcoal factory. They used the larger remnants of each tree to make chairs and sent the rest to the charcoal factory. The chairs—straight and rocking, with cowhide seats—were soon in demand in fifteen states (including Texas). The charcoal was sold to regional laboratories, apothecaries and railroads.

The residents of Kristenstad dairy-farmed; raised their own livestock (cattle, goats, sheep, hogs, chickens and turkey); produced their own lard, milk and butter; planted and harvested their own fruits and vegetables (including corn, peanuts and native pecans); cultivated their own hay and cotton (from which they made their own clothes); and picked wild grapes (which they concocted into a salable grape juice). A community-wide co-op called the Kristenstad Marketing Association gathered and delivered the farm surplus to local markets. The children of the colony also took part in

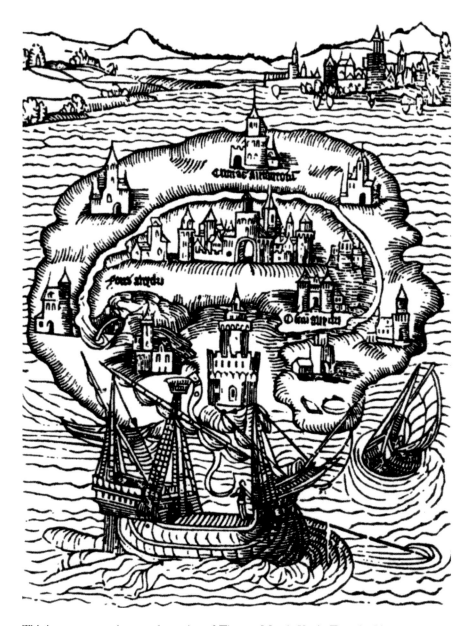

This image appears in an early version of Thomas More's *Utopia*. Texas had its own Utopian experiment along the interior banks of the De Cordova Bend in the Brazos River near Granbury.

the farm and harvest efforts, gathering herbs, roots, barks and flowers for growing markets in the medicinal industry.

Soon, Kristenstad had a post office, a general store, a cement plant and a schoolhouse that featured a piano and radio and doubled as a site for socials every Saturday night. And below the natural spring, a large arbor composed of large vine-clad trees served as an open-air church that welcomed any minister as long as his sermons were nondenominational.

For the convenience of the cooperative and its commercial interests, the community created its own monetary system based on non-precious metal tokens. The tokens were stamped in increments of five, ten, twenty-five and fifty cents but transferrable only within Kristenstad.

When state and national newspapers began calling on the successful undertaking in the mid-1930s, descriptions of Kristenstad were typically Utopian, specifically noting that residents seemed exceptionally content with Kristenstad's cooperative model and exhibited no interest in taking advantage of their neighbors.

This, of course, was viewed by some observers as subtly un-American or anti-capitalist, but Christensen himself was quick to downplay talk of Utopianism, Communism, etc., insisting that the first principle of Kristenstad was a simple equation that characterizes Americanism: folks there simply wanted to establish a sustainable lifestyle based on useful work and individual efficiency in relation to available natural resources.

Try as Christensen might, however, the aberrant collective satisfaction and stability inherent in the experiment was hard to conceal. In the first five years of the colony's existence, there were no arrests or lawsuits and no crime. Differences were settled by peaceful, fair-minded arbitration.

For another year or two, Kristenstad continued to do well, but the Great Depression worsened and eventually crept into De Cordova Bend. Agricultural prices fell and perilously undermined most of the products the community had to sell. Then, the chair factory burned down and the community endured a terrible drought, followed by a relentless winter. The already devalued livestock perished in droves, and crop harvests dwindled.

Christensen vowed to rebuild the chair factory and keep the settlement on its feet, but the string of bad news never let up. The proposed dam was postponed repeatedly, and the colony never got a suitable road through the Narrows. Then, in October 1937, Christensen himself passed away at sixty-one years of age.

Christensen's widow would later claim that the strain of trying to preserve Kristenstad had killed her husband, but she also indicated that one of the

final straws was the increasing dissent caused by a strain of Communism that eventually began to evolve there. Without Christensen's guidance, the community floundered.

In 1938, the De Cordova Bend colony of Kristenstad defaulted on its note with the six-thousand-acre tract's previous owners, and Hood County district judge Sam R. Russell issued a court order to return it to them forthwith.

The residents of the Texas Utopia moved away, and Christensen's beneficent experiment passed into history.

De Cordova Bend Dam was permitted in 1964 and completed in 1969.

AURORA CRASH

On April 17, 1897, the early risers of Aurora were stunned by the sudden appearance of a flying object heading toward the town just below the clouds. It sputtered over the town square, dropped lower and reportedly crashed into a windmill owned by Judge J.S. Proctor. There was a terrific explosion, and it scattered wreckage across several acres and toppled the windmill into Proctor's flower garden.

According to the April 19 edition of the *Dallas Morning News*, the craft was reported to have had one passenger on board whom the citizens of Aurora assumed was its pilot. His (or its) body was "badly disfigured" by the crash and explosion, but onlookers could tell (as the *Fort Worth Register* put it) that "he was not an inhabitant of this world."

Dallas Morning News stringer S.E. Hayden wrote that a U.S. Army Signal Service officer named T.J. Weems was present at the aftermath and suggested that the pilot was probably Martian. Hayden also reported that wreckage sifters said the ship was too severely damaged for them to surmise the craft's "motive power" but that it appeared to be constructed of an unknown alloy resembling a combination of aluminum and silver and "must have weighed several tons."

The citizens of Aurora also reportedly found documents covered with indecipherable hieroglyphics on the deceased pilot and assumed they were

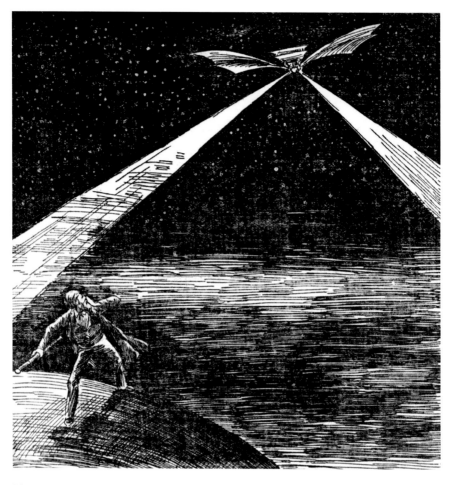

Mysterious airship—possibly Martian—from the *Saint Paul Globe* (Minnesota), April 13, 1897. Unidentified flying objects and airships were reported across the United States in 1897.

a record of his travels. Hayden's account said the town was "full of people who are viewing the wreckage and gathering specimens of strange metal from the debris."

The following Easter morning, the townspeople gathered up the remains of the unfortunate pilot and gave him (or it) a Christian burial in the Aurora Cemetery. And the legend of the Aurora "spaceman" was born.

Lone Star Starships

Eleven days before a flying object smashed into the Proctor windmill, the *Dallas Morning News* reported that a Denison man saw a large, "brilliantly illuminated" airship moving in a northerly direction at speeds upward of fifty miles per hour around three o'clock in the morning. The unidentified man (whom the *News* pointed out was trustworthy and a Mason) said the craft was traveling at approximately a quarter of a mile above the ground and made a "peculiar swishing" noise as it passed.

A day later, around 11:00 p.m. in Guthrie, Oklahoma, Landlord Trumbull spotted a "dark looking" object in the skies above the city from the Arlington Hotel. According to the *Terrell Times-Star*, Trumbull said its outline was "indistinct" and referred to it as a "shadow object" but added that the craft also featured an intermittent bright searchlight "which seemed to be thrown out in different directions" in an alternating fashion. Trumbull also claimed he called the strange object to several people's attention and they watched it move back and forth rapidly, descend almost to the ground and then rise "straight into the air at great speed" and disappear.

On April 8, a strange object was seen passing over Dallas. On the evening of April 9, an unidentified object was reported in the skies above Paris, Texas. And on April 12, several witnesses saw an object flying over southern Oklahoma.

On the night of April 14, an unidentified flying object was seen over Fort Worth. Also, the same evening, another anonymous but reportedly credible man saw a flying object over Denton. The man caught sight of the craft while standing in his backyard and studying the stars with the aid of powerful marine glasses. He said it was approximately fifty feet long and traveling at a slow speed about a half mile above the earth. He watched it move in a southwesterly direction for a few minutes and then, "with almost a jump," it began moving southeasterly "at a terrific rate" and remained in the field of his marine glasses for almost twenty minutes. He added that the craft was cigar-shaped with a "broad tail or steering sail behind" and a searchlight "beside which even the luminosity of the moon paled."

On the night of April 15, at around 8:30 p.m., several residents of Corsicana (including a party of eight at the home of Judge Sam R. Frost) saw what was described as "a bright light a long distance from the earth" moving at a "fast speed across the firmament." A local doctor named Wills said the object was definitely not a meteor because its lights were "intermittent, appearing to come and go."

Thirty minutes later, an unidentified "machine" was seen in the skies above Weatherford by several witnesses, including an *Austin American-Statesman* correspondent. Then a Texas and Pacific Railroad night chief operator named Dunlop reported what he described as a sixty-foot aircraft (pointed at both ends, with a searchlight in front and several smaller lights down the sides) in the skies above Cresson. And Railroad Conductor W.W. Hanney and his wife and mother claimed they saw a large dark object with a bright searchlight exploring the skies above Fort Worth as they sat on their front porch.

On April 16, at approximately 2:00 a.m., J.A. Black, of Paris, Texas, spotted a gigantic luminous cloud moving in his direction after returning home from his night watchman's job at the Paris Oil and Cotton company. His dog began moaning pitifully, and the approaching entity unsettled Black so that he ran across the street and awakened his neighbor, Jim Smith. Together they spied a "monster airship" that was almost two hundred feet long, and Smith described it as "the return of Noah's Ark with wing-like attachments."

On the following evening, a man named John German saw a mysterious airship passing over the north side of Bonham around 8:15 p.m. and said it pierced the darkness "with the brilliancy of the headlight of a railroad engine." Then, according to the *Fort Worth Register*, H.A. Hambright, B.T. Hambright, A.J. Jones, Nute Reives and Elmer Helm saw an airship pass over Rhome (a town neighboring Aurora to the east) around 8:30 p.m. traveling at approximately 150 miles per hour in a westerly direction. Later, according to *Dallas Morning News* reports, J.F. Wade spotted an "aerial monster…scudding along just above the tops of houses" in Cleburne; Jack Farley saw an object with "outstretched wings" and a "big headlight" above Fort Worth; and Captain J.H. Wright, C.P. Witherspoon and W.H Howard claimed to have seen a flying object near Mansfield.

Other newspaper reports also placed mysterious aircraft in the skies above north Texas on April 16. There were sightings in Texarkana, Forney, Sherman, Tioga, Ladonia, Greenville, Ennis, Garland, Oak Cliff, Whitney, Hillsboro and again at Denison. One Granbury account even mentioned a company of local militiamen firing their rifles at an unidentified flying object and waking up the whole town.

On April 17, *Dallas Morning News* accounts placed unidentified flying objects in Beaumont and Stephenville; the *Austin American-Statesman* reported one in Paris; and the *Galveston Daily News* mentioned one in Galveston before, like the *Dallas Morning News*, reporting the crash in Aurora.

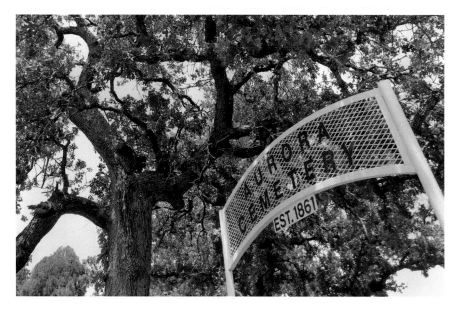

The entrance to the Aurora Cemetery. A historical marker indicates that Aurora citizens buried a spaceship pilot there in 1897. *Photo by author.*

Though the April 17 Aurora crash of an unidentified flying object possibly carrying a Martian pilot was reported in two major Texas newspapers, the sightings didn't stop. On April 18, additional reports were recorded in eight Texas communities, including four in what came to be known as the Metroplex. On April 19, there were accounts from thirteen Texas communities, including three in the Metroplex and one that detailed an airship hoax gone awry. Some pranksters in Plano attached a portion of cotton twine to a bird's leg, doused it in turpentine and then lit it. Unfortunately, the bird flew off in a panic and lit on the town's two-story schoolhouse.

On April 20, unidentified flying objects were reported in four Texas communities, including Mineral Wells. From April 21 to May 12, there were twenty-eight new sightings in Texas before the last one in Fort Worth reported by the *Dallas Times Herald*. According to the May 13 edition of the *Herald*, the wife of a Captain Scobie "called him to see something strange passing over" Fort Worth the night before, and he went out into their yard to get a better look. He discovered a "dark object with a wonderfully bright light on top of it" traveling above the small clouds in the sky and moving rapidly in a southeasterly direction.

In a matter of thirty-eight days, unidentified flying objects were spotted in Texas skies hundreds of times and across dozens of communities. Some thought they were Martian, some believed they were balloon-harnessed airships and some thought they were harbingers of God's judgment. Others claimed they were simply an elaborate hoax.

Martian Menace

In the April 20, 1897 edition of the *Austin American-Statesman*, after an account of one R.H. Cousins claiming that what he saw wasn't an airship but simply a "moving light," an associate of the *Statesman* posed an unsettling question: "With these soldiers of Mars cavorting around over our heads, do you think there is any danger to us of the earth?"

Folks around the state and the nation were legitimately concerned that the strange aircraft seen in the skies above Texas were Martian and perhaps dangerous. The new, high-powered telescopes of the day had recently allowed professional and amateur astronomers alike to look at Mars more closely, and many believed it had man-made canals on its surface. In fact, several scientists and sensationalists insisted that, for the first time in human history, there was evidence that we were not alone in the universe. The concept was frightening and heretical, and though the science behind it was suspect, it caught on in the public's imagination.

T.J. Weems, the Army Signal Service officer who initially suggested that the deceased, disfigured pilot of the airship that crashed at Aurora was Martian, was probably making an honest assumption. If the aircraft was not of this world, Mars would have been most late nineteenth-century laymen's first guess as to its point of origin.

Fortunately, as documented by unanimous eyewitness accounts, there was no evidence that the mysterious aircraft during this period had any menacing intentions. If the pilot who crashed into Judge Proctor's windmill was otherworldly, he was probably simply here to survey the landscape. The scarier implication of course, was that he might not have been alone. Similar skyward entities had been seen in too many other places.

MAN-MADE AIRSHIP

The first official dirigible or "airship" flight in the United States was recorded in Oakland, California, in 1904, but as far back as the Civil War, the concept had been discussed and explored. In fact, an inventor named Dr. Solomon Andrews had informed President Abraham Lincoln that he could produce an airship "for reconnaissance" to aid Union armies, and in June 1863, he did exactly that.

According to an account later published in *Popular Science* (January 1932), "Dr. Andrews' airship flew into the wind on its maiden voyage, reaching an altitude of 200 feet and landing safely." Then, on September 4, 1863, after some engineering modifications, Andrews held an aerial exhibition for the press. According to a *New York Herald* account (from September 8, 1863), Andrews's airship completed a few test flights and then set a course upward, spiraling in half-mile circles until it rose above the clouds. The *Herald* correspondent noted that the craft contained twenty-six thousand cubic feet of hydrogen and carried a car beneath that was twelve feet long and could carry up to three passengers. Press representatives declined to comment on the airship's "propelling power and motive apparatus" because "such a machine in the hands of Jeff Davis" would endanger the Union cause.

Were the unidentified flying objects in the skies above Texas in 1897 actually secret human-engineered airships? Some researchers thought so, and some local accounts supported this possibility.

On April 10, the *Dallas Morning News* reported rumors that a man named McKnight had been working on an airship at "U.S. Marshall Williams' Ranch" and that he had been testing it at night. The *News* never located the "Williams" ranch, and the mention was never substantiated.

On April 17, the *Dallas Times Herald* reported that a Fort Worth man named L.E. James saw a seven-foot-tall man get out of an airship near a Fort Worth park, secure some of the vessel's lashings and then re-board and disappear into the sky.

On April 18, the *Dallas Morning News* reported that a man named J.N. Floyd claimed that when he saw an unidentified ship over Garland, he could "see the engineer operating the machine." Also on the same day, the *Fort Worth Register* reported that a telegraph line repairman named Pat C. Byrnes witnessed an airship on the ground seven miles west of Cisco.

One theory indicated the unidentified flying objects were piloted by gangs of "cracksmen" who utilized X-rays on the ships to look through the walls

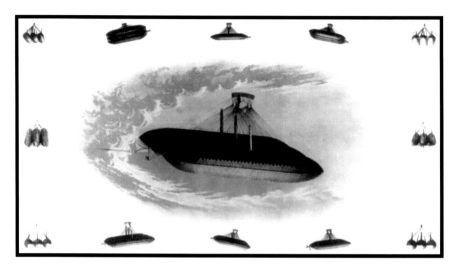

A photo of a lithograph featuring Dr. Solomon Andrews's airship, the *Aereon*. In 1863,
Dr. Andrews told President Lincoln that he could produce airships that could be utilized
for Civil War reconnaissance missions. Andrews later proposed the *Aereon* for crossing the
Atlantic Ocean. *Courtesy of the United States Library of Congress.*

of houses and bank vaults to pinpoint promising targets. Another account
claimed that the vessel was operated by New York capitalists taking their new
investment for a test drive, and still another account suggested the craft was
helmed by descendants of the Ten Tribes of Israel who currently resided "in
a large body of land beyond the polar area of the North Pole."

From October 1896 to mid-1897, there were over one thousand
documented newspaper accounts of flying objects and airships across the
United States, allegedly being piloted by everyone from covert government
agencies to invaders from outer space. It is impossible to say which accounts
were faithful, fictional or fantastical, but it's probably safe to say that of the
thousands of witnesses who claimed to have seen an airship, mysterious object
or aerial wonder, someone somewhere saw something traversing American
airspace and, proverbially speaking, what goes up, must come down. The
citizens of Aurora may have witnessed something that came down. And the
creature found in the charred wreckage around Judge Proctor's demolished
windmill may actually have been one of us.

Heavenly Inspectors

In many communities, the inexplicable flying object sightings inspired superstition. In the April 17 edition of the *Austin American-Statesman*, one writer direly remarked on what the appearances and sightings of the airships meant: "All the predictions of prophecy concerning what would happen on the face of the earth have been verified, and if these airships are supernatural the heavens are about to declare the fulfillment of prophecy."

Soon after, the *San Antonio Express* reported that religious leaders proclaimed that if the unidentified flying objects were "earthly devices," they would "be seen by day as well as night," adding that local preachers believed the "airships" were "from another world" and acting as "advent" couriers of the second coming of Christ.

Then, after C.W. Beale and F.D. Hahns saw a "mysterious vehicle" in the skies above Ennis on April 17, the *Dallas Morning News* commented that "close students of the Bible are apprehensive that the end of time is drawing near and that the strange visitations are heavenly inspectors going about to judge the world."

The skyward entities that populated the Texas heavens in the early spring of 1897 struck many as disturbing portents, and perhaps none as much as the citizens of Aurora. The town was no stranger to cataclysms.

In the mid-1880s, Aurora boasted two hotels, two cotton gins, two schools, three doctors and more than a dozen businesses. With a population estimated at approximately three thousand people, it was the largest community in Wise County. But by 1897, its fortunes had changed drastically. First, the community suffered a horrific spotted fever (cerebral meningitis) outbreak that killed hundreds and maimed or blinded hundreds more. Next, a boll weevil infestation ravaged the town's lucrative cotton industry. Then the entire western business district and several homes were destroyed by fire. And finally—virtually a deathblow—Aurora lost a planned Fort Worth and Denver City railroad track to nearby Rhome. Many of the folks who survived these tribulations followed the railroad to Rhome or moved to nearby Newark. When the mysterious airship slammed into Proctor's windmill the day before Easter, Aurora was practically already a ghost town and a snake-bit community at that.

Much has been made of the narrative that indicates the inhabitants of Aurora simply collected the remains of the disfigured pilot and his undecipherable writings and quaintly interred him the day after the crash. Some researchers say this chronology invites suspicion. Some critics wonder why the Aurorans didn't

have the body autopsied or put on display. Others suggest that it's curious that no part or parcel of the event ever appeared in museums or carnival sideshows. But skeptics may forget that the burial took place on Easter in a town recently beset by fire, brimstone and pestilence on a locally biblical scale. It could be that the Aurorans simply didn't want to invite additional calamities.

HYPNOTISM, BAD WHISKEY OR MENTAL SOMERSAULTS

Regarding the mysterious objects traversing the skies in this period, "some are utterly skeptic and suggest that it is a new fad with those people who are unfortunate enough to 'see things.' Formerly, their minds conjured up blue monkeys, Nile-like saurians and other creeping things equally disagreeable for the mind to dwell upon. They suggest that having exhausted the catalog of things that creep, they have by some mental somersault invaded the realm of flying things, and hence the airship." So spake a columnist for the *Dallas Times Herald* on April 18, 1897.

The following day, the *Galveston Daily News* reported that a Dr. E. Stuart, "an acknowledged authority in metaphysics," posited that the entire affair was due to hypnotism and bad whiskey.

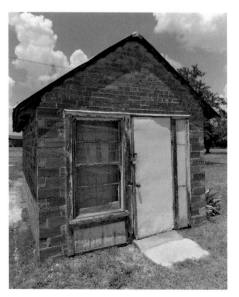

From April 1897 to the present day, cynics have relegated the sightings to figments of collective imagination or products of mass hysteria. Communal delusion can certainly not be ruled out, but neither can honest appraisal under the circumstances or the era's atmosphere of human gullibility. Perhaps there were strange figures

The red brick outbuilding of Brawley and Etta Oates sits on the original site of Judge Proctor's toppled windmill (or windlass). *Photo by author.*

moving across the heavens in April 1897. And perhaps, also, their presence was being mischaracterized by exploitative commentators and con men.

As previously discussed, the existence of life on Mars was popularly suggested. And in the *Fort Worth Register* in the days leading up to the Aurora crash, serious journalists were discussing mysterious hieroglyphics found on Aztec manuscripts allegedly native to Iowa!

The year 1897 was a time of signs and wonders, and many of both were misinterpreted or misappropriated. A new century was approaching, and people were fearful and superstitious. If charlatanry was afoot, it was probably due more to the chroniclers of the era than the participants. And the same could be said of the Aurora crash.

Twentieth-Century Reemergence

In 1945, Brawley and Etta Oates bought the Proctor place, and one of their first projects was to clean out the old well that sat below the toppled windmill and use it as a water source. Over the next decade or so, the family reportedly developed strange cysts and goiters, and Brawley suffered severe bouts of arthritis. The Oateses were afraid the water from the well might be radioactive, and in 1957, they sealed it and placed a red brick outbuilding on top. Later, Etta claimed that for years nothing would grow on the spot where the spaceship was alleged to have crashed.

In 1966, a British publication called the *Flying Saucer Review* did a brief, cursory investigation of the Aurora crash and concluded that the entire event was fabricated to draw attention to the town because it was dying out.

In May 1973, the story of the Aurora crash was revived by *Dallas Times Herald* writer Bill Case, and his reporting garnered worldwide coverage. Case wrote a few stories detailing the incident, and interest in the legend took on a life of its own.

UFO researchers began combing the Aurora countryside with metal detectors. They claimed the metal readings they recorded at the crash site (which was then occupied by a chain-link chicken coop) matched those taken at the alien's grave. A Fort Worth Civil Defense official named B.F. Myers Jr. arrived with a Geiger Counter and checked the grave and the crash site and found no signs of radiation. Undeterred, UFO experts called for the exhumation of the alien's body, and Aurora residents threatened to file an injunction. The town marshal, H.R. Idell, and other concerned

Aurora residents began guarding the cemetery around the clock to prevent researchers and fanatics excavating or tampering with the grave sites.

In the midst of the hubbub, Dr. David Redden of the University of North Texas (then called North Texas State University) Department of Biological Sciences discovered several metal samples at the crash site and took them to UNT to be examined. UNT physicist Dr. Thomas J. Gray studied some of the fragments and indicated that one was "unusual because it was 75% iron, but lacked many of the properties common to iron." Gray was specifically puzzled by the fact that the iron fragment in question was not magnetic. "I don't mean by my comments to indicate whether this is of terrestrial or extraterrestrial origin," Gray said, "but the physics of that much iron not being magnetic stirs my curiosity as a scientist."

Scientific treasure hunter Fred N. Kelley unearthed about twelve pieces of lightweight metal fragments, the likes of which he claimed to have never seen before. Additional lab investigations reported that some shards "had an unknown crystalline structure" and others looked as if they had been melted by intense heat and "splattered on the ground."

In mid-June 1973, the day after the cemetery patrols ceased, a marker that was purported to be the headstone of the alien's grave site was stolen. Case and *Fort Worth Star-Telegram* reporter Jim Marrs returned to the cemetery to examine the spot where the alien's grave marker had been and discovered three small holes drilled into the plot. Case ran a metal detector over the spot; the readings that had matched those at the crash site were now nonexistent. Case suggested that evidence shedding light on the remains of the alien had obviously been removed, and Marrs and Case both believed the U.S. government had been involved.

In 1976, the State of Texas placed a historical marker at the Aurora Cemetery listing brief genealogical information, mentioning the spotted fever outbreak and indicating that the cemetery "is well-known because of the legend that a spaceship crashed nearby in 1897 and the pilot, killed in the crash, was buried here."

WITNESSES

In 1973, ninety-one-year-old Aurora resident Mary Evans told news reporters that she had been fifteen at the time of the crash and her parents had told her an airship "had exploded" and the pilot was "torn up." She

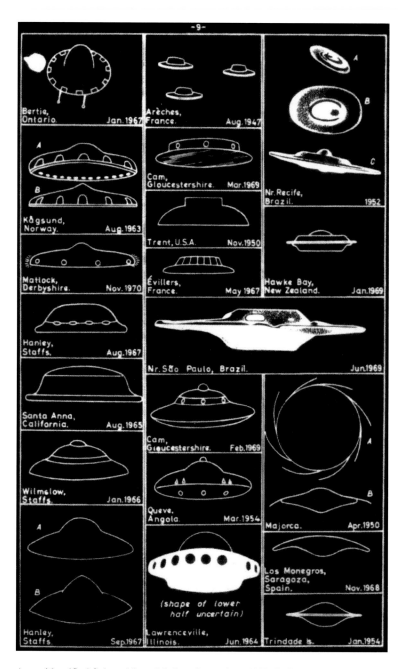

An unidentified flying object sighting chart, circa 1969. It features many of what came to be known as flying saucer–like objects, the first of which was reported by a Denison man named John Martin in 1878. *Courtesy of yhe National Archives, UK.*

herself had not witnessed the event or examined the aftermath because her parents hadn't let her accompany them when they visited the crash site. In the late 1970s, Robbie Hanson, who had been a twelve-year-old resident of Aurora at the time of the alleged crash, claimed it was a hoax. "I was in school that day," she said, "and it just never happened."

In 1990, eighty-three-year-old Aurora resident Waymon Reese concurred with Hanson. "There wasn't a thing to it," he said. "Never was."

Reese, who knew several of the old-timers who lived in the area at the time of the event, said they concocted it outright or simply embellished it until it was a modern-day fairy tale because they had nothing better to do than "sit around, whittle and joke."

Longtime Wise County Historical Commission chairwoman Rosalie Gregg agreed with Reese. "Judge Proctor didn't even have a windmill," she said.

Others corroborated Evans's claims. Decatur resident Carolyn Dodson said her grandmother, Nova Bowman, moved to Aurora in 1895 and used to tell her that, though too young to understand everything at the time, she remembered a "great commotion" and "large number of people in town" after the crash. James Idell, the son of former Town Marshal H.R. Idell, is reported to have said his grandfather helped bury the alien and described it as "a three-foot-tall, big-headed spaceman." Everett Sloan claimed his father was in T.J. Weems's blacksmith shop when the airship crashed and he was the one who first spotted the deceased pilot. Sloan also claimed his father helped transport the alien to the cemetery. And during the height of the 1973 UFO craze in Aurora, eighty-three-year-old Charlie C. Stephens told Marrs that he and his father had seen the flying object that crashed in the town while they were putting some livestock out to pasture. Stephens described the craft as cigar-shaped with a bright light and said it flew by very low. And not long after they saw it, he and his father heard a loud explosion and saw fire in the sky toward the town. Stephens claimed he wanted to go see what had happened, but his father told him they had to "finish their chores." The next day, Stephens's father took a horse to town and saw what he described as a large collection of twisted metal and scorched debris.

Later, the *Wise County Times* reported that Stephens reaffirmed his sighting and explained the Proctor windmill discrepancy. "It wasn't a windmill," Stephens said. "It was a wooden windlass built over the well about 18 feet high and used to hall up the sump."

The Site Today

Aurora is twenty-five miles northwest of downtown Fort Worth and a little over a mile west of Highway 287. The crash site lies between a paved west turn off State Highway 114 leading to the Aurora Baptist Church and a gravel west turn off State Highway 114 leading to the Aurora ballpark. Both turns ascend up to a hill or mild bluff (that comprises the second-highest point in Wise County), and the red brick outbuilding that Brawley and Etta Oates erected over the bad well still inhabits the spot where the Proctor windmill or windlass once sat.

FATHER KELLER

In the early stages of World War I, the Protestant town of Slaton perceived a traitor in its midst. The new local Catholic priest, Father Joseph M. Keller, had been born in Aachen, Germany.

It was rumored that Germans or folks of German descent who were living in America were spying for the Kaiser, and Father Keller fit the rumor-mill profile to a T. He had immigrated to America in 1916 and was ordained in Kenrick, Missouri, before accepting the charge of the Missionary Parish of Slaton in early 1917. Not long after the United States joined the war, the local newspaper, the *Slatonite*, began condemning all Germans as "Huns" and "barbarians," and Father Keller took offense. He initially appealed to the *Slatonite* editor's sense of reason, but the editor was unimpressed, and their disagreement was heated. To make matters worse, as World War I wore on, Father Keller was disinclined to denounce his homeland and reportedly had to be persuaded to take down a photo of Kaiser Wilhelm in his office.

Having accepted the Catholic mission in Slaton because he was intrigued by the idea of the American West, Father Keller soon found himself a victim of his own romantic notions. The rural community of Slaton was provincial. The Ku Klux Klan was well represented at the local and county levels of law enforcement, and the citizens of Slaton viewed the new German priest and the

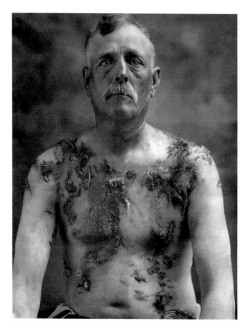

John Meints, a German American farmer living in Luverne, Minnesota, was—like Father Joseph Keller—whipped and then tarred and feathered because his neighbors felt he wasn't loyal enough to the American cause in World War I. Meints reported the incident to the local authorities and sued the thirty-two men involved in the assault for $100,000. The subsequent trial produced over one thousand pages of testimony, and the U.S. District Court jury sided with Meints's assailants, concluding that Meints was disloyal. Meints appealed the ruling in 1922 and settled out of court for $6,000. *Courtesy of the United States National Archives and Records Administration.*

growing Catholic presence in the area with suspicion and dismay.

By 1918, Father Keller was so unpopular that some of his own parishioners petitioned Bishop Joseph P. Lynch (of the Diocese of Dallas) to replace him, but Bishop Lynch refused and ordered the petitioners to afford Keller the confidence and respect he deserved as their priest.

A whisper campaign ensued, indicating that Father Keller was not only a spy but also a lecher and an adulterer and was infected with syphilis. These accusations appeared to be groundless, but the gossip of his improprieties continued. Bishop Lynch eventually investigated Father Keller but found no evidence of serious personal or professional shortcomings.

In 1919, after the war ended, Father Keller traveled to Abilene to procure U.S. citizenship; two citizens of Slaton followed him in an attempt to testify against him at his citizenship hearing.

In early 1920, the Missionary Parish of Slaton began construction on a new, larger church and had plans to establish a parochial school later in the year. Many Protestant citizens of Slaton felt threatened by the swelling Catholic populations and blamed Father Keller.

In early 1922, after the new church was up and the parochial school was off and running, a new set of rumors circulated, this time alleging that Father Keller had broken the seal of confession. He continued administering his parish duties undeterred, even successfully petitioning for a new Catholic mission in nearby Littlefield.

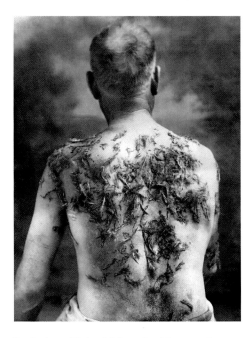

Back view of John Meints after his tar and feathering. *Courtesy of the United States National Archives and Records Administration.*

On March 4, 1922, at around 8:45 p.m., Father Keller heard a loud knock at his door. When he answered the knock, six gunmen in masks seized him and dragged him from his doorway to a waiting car. The gunmen tied his hands, stuffed him into the back seat of the vehicle and then sped out of town heading north.

Once they were about a mile outside Slaton, Father Keller's kidnappers parked their car in the cover of darkness and presented him to a twenty- to thirty-man gathering of some of his most ardent critics and detractors. They pulled off his robe and tore away his pajama bottoms. They restrained him, lectured him and viciously whipped him, subjecting him to approximately twenty lashes. Then they dumped searing tar over his head and shoulders, burning his flesh and lash wounds, and tore open a pillow to apply a coat of feathers. Father Keller was instructed to leave Slaton within twenty-four hours and then left lying alone in the field, trembling beneath a coat of drying tar.

Father Keller struggled to his feet and painfully trudged toward Slaton. He limped to the office of a local doctor named Tucker wearing only one slipper. Dr. Tucker spent most of the night scrubbing away the tar and feathers from Father Keller's skin with kerosene, and the next morning, Father Keller left on an early train.

The March 7, 1922 edition of the *Lubbock Avalanche-Journal* insisted that the Lubbock County citizens responsible for the assault of Father Keller had done little more than their duty and were justified because he was guilty of adultery, misogyny and "other things unbecoming to a citizen of America." In a later account published in a memoir entitled *Pioneer Preacher of the Plains*, longtime preacher John Pettigrew Hardesty relegated Father Keller's tar and feathering to one of the "exciting times during those days" and suggested

that if the group responsible hadn't tarred and feathered Father Keller, any number of other parties would have.

After leaving Slaton, Father Keller spent most of the next year recovering at the Sisters of Precious Blood Convent just outside St. Louis, Missouri. When the trauma and agony of the Slaton assault were far enough removed from his mind, he joined the Milwaukee, Wisconsin Diocese. For the next several years, he served as assistant pastor at St. Joseph's Church in Milwaukee, assistant pastor at St. Peter's Church in Beaver Dam, pastor of St. Francis Church in Brighton and pastor of St. Boniface Church in Goldendale (where he built a rectory).

On July 1, 1933, Father Keller became the pastor of St. Mary's Catholic Church in Milwaukee and remained there until his death at the age of fifty-eight on December 18, 1939. He had been ill for most of 1938 and had entered St. Joseph's Hospital on October 2.

The money from Father Keller's life insurance policy went to the Catholic Diocese of Amarillo to serve the needs of his original parish in Slaton, and on August 20, 1972, the *Lubbock Avalanche-Journal* noted that the Sacred Heart Catholic Church of Littlefield celebrated its fiftieth anniversary with a reading of Father Joseph M. Keller's original petition letter.

INDIAN FORTRESS

When you see the town of Spanish Fort on a Texas map, it jumps out at you. It's tucked into a long bend of the Red River, just north of Nocona.

You know—or at least think you know—that the Spanish didn't have any forts that far north in Texas. You wonder if the structure is still intact. You wonder why you've never heard of it before. Your initial interest is rewarded by intriguing revelations.

First, the fort, which included wooden stockades, entrenchments and a moat (yes, a moat—in Texas), is long gone. A historical marker stands on the original location.

Second, "Spanish" fort is wholly inaccurate. The fortification was actually a French structure built at the location of a preexisting Taovayas Indian village around 1719. The Taovayas had just moved into the region when the French were beginning to venture farther west along the Red River. The two peoples quickly became successful trading partners.

Third, when the only major defense of the fort was mounted in 1759, the attacking forces were actually Spanish and the fort defenders were Taovayas, Wichita and Comanche Indians at least rudimentarily trained by a previous French contingent. When an early Anglo settler visited the ruins one hundred years later, he simply assumed they were Spanish. Hence the town name, "Spanish Fort."

A Spanish Fort historical marker relief—depicting a Taovayas warrior—is mounted on an eight-foot-tall shaft of red granite in the town square. *Photo by author.*

And fourth, the Native American rout of the Spanish at the French Taovayas fortress marked Spain's earliest defeat in Texas and probably kept them from expanding farther north.

In the mid-1750s, there were rumors of a lucrative silver-mining prospect near present-day Menard, and local Lipan Apache groups were reportedly interested in converting to Christianity. The Spanish established Mission San Saba and Presidio San Saba a few miles apart along the San Saba River to look into the silver claims and proselytize the Apache. Not long after the two complexes were completed, the Apaches were boasting about their mighty new partners.

When word of a new force in the region reached the Comanches, they marshaled some of their Wichita, Taovayas and Yojuane allies and headed south. On the morning of March 16, 1759, the Comanche and a two-thousand-warrior confederacy attacked the mission, massacred most of its inhabitants and put most of the mission buildings under the torch.

Reduced by various maneuvers in the area, the scantily numbered Spanish troops garrisoned at Presidio San Saba helplessly witnessed the upstream smoke and gunfire.

The enraged Spanish commissioned Presidio San Saba commandant Colonel Diego Ortiz Parilla to visit the same death and destruction wrought at Mission San Saba upon the Comanche and their allies. In late September, Parilla marshaled a force composed of approximately six hundred Spaniards, militiamen and Lipan Apaches northward, traveling west of the lower Cross Timbers.

On October 2, Parilla's forces caught a Tonkawa village on the north bank of the Brazos River by surprise and quickly subdued it, taking 149 prisoners. When the Tonkawa captives realized Parilla was looking for the Taovayas, they told him where their camp was located.

Utilizing the Tonkawa as guides, Parilla proceeded to the Red River and turned east. On October 7, they discovered an old fortification flying the French colors on the Red River. It was protected by a tributary stream moat and—to the Spaniards' stupefaction and bewilderment—manned by Taovayas, Wichita and Comanche Indians armed with French muskets.

The garrison Indians attacked the Spanish and then drew back. Parilla's troops attempted to advance on the Taovayas forces repeatedly but each time were repulsed by coordinated gunfire from behind the fortification walls. And when the Spanish advances turned away, their garrison foes invariably counterattacked, retreating only to exchange empty muskets with reloaded ones from Indians on foot.

Initially dumbfounded by the Taovayas fortress, the Spanish were also astonished by their leader. Clothed in white buckskin and a helmet adorned with handsome feathers, he was fierce and animated behind the fortress walls and uncannily proficient outside them. He led several Taovayas assaults on the Spanish and was eventually struck down, but he inspired his comrades and left an indelible impression on his foes.

Parilla's cavalry charges were ineffective, so he proceeded to bombard the Indian fortifications with cannon. The barrage had little effect. In fact, the Taovayas confederacy began to greet each cannon fire with howls of laughter. And during that period, the Spanish were constantly harassed by musket volleys from the palisaded fortress stockades and attacked on all sides by opportunistic waves of Indian infantry and cavalry. By nightfall, the Spanish verged on being overrun, so they retreated hastily, leaving their supply train and cannon behind.

It took Parilla's disgraced soldiers eighteen days to return to Presidio San Saba, and the Comanche harassed them all the way. The Spanish never sought further military redress and soon abandoned the San Saba mission and presidio. Within a decade, there was no European influence left in the Spanish Fort area, but in 1771, the lieutenant governor of Spanish Louisiana normalized relations with the Taovayas settlement there via treaty and named it San Teodoro. The Taovayas were decimated by smallpox in the early 1800s and abandoned San Teodoro shortly thereafter.

The Comanche remained a force on the Texas plains until the late nineteenth century. The ranks of the Taovayas shrank and eventually folded in with the Wichita.

Today, all that remains of their fortified defense against and subsequent defeat of the Spanish is a historical marker mounted on an eight-foot-tall shaft of red granite in the town square and the Taovayas Indian Bridge across the Red River, connecting Texas FM 677 to OK 89.

FENCE-CUTTERS' WAR

I'm going to leave old Texas now,
They've got no use for the long horn cow.

They've plowed and fenced my cattle range,
And the people here are all so strange.

I'll take my horse, I'll take my rope,
And hit the trail upon a lope.

Say adios to the Alamo,
And turn my face towards Mexico.
—traditional cowboy song

Though it seems difficult to envision now, there was a time when Texans bristled at the notion of their natural resources being privatized. The cattle drive itself—such an integral part of the Lone Star economy—was predicated on communal pastures and shared water sources.

The Texas of legend and popular imagination was wide open and untethered. The spread of Anglo settlements pockmarked the state throughout the nineteenth century, and the railroads sliced and stitched the

landscape willy-nilly, but the eastern wilderness and the western frontier remained somewhat intact. Texas was "Old Texas" until it abruptly found itself tied and bound.

It started in 1875 when barbed wire was introduced. Texans were unimpressed at first, particularly as the contrivance had originated in the North. But it was eventually utilized in isolated applications and proved durable and practical, and this made it an irrepressible prospect. Traditional fencing materials like timber and stone were hard to come by in many parts of the state, and in no time the larger ranches—often backed by northern or foreign investors—were purchasing barbed wire by the trainload and subjugating horizon-to-horizon stretches of the Texas frontier with little regard for convenience or public access.

As the use of barbed wire became more widespread, it frequently involved sheer opportunism and flagrant public obstruction. Barbed-wire installers were fencing in property that didn't belong to them, restricting access to long-held community water sources, obstructing cattle drives, blocking common thoroughfares, impeding postal routes, etc. Concerned parties contacted their state legislators, but their complaints were ignored or answered with no suggestions for resolution. By the late 1870s, citizens were taking matters into their own hands.

Disgruntled Texans began carrying fence-cutting pliers (or wire cutters) and simply cutting stretches of barbed wire that were in their way. As their numbers grew, they organized in clandestine groups (with official and unofficial names, i.e., the owls, javelinas, etc.) and began cutting down large sections of fencing at night.

In 1878, the new Texas Greenback Party (which was directly affiliated with the national Greenback Party)—an anti-monopoly group that advocated reducing the special treatment afforded to the railroad industry, eliminating redundant or otherwise useless governmental offices, establishing a tax-supported public school system and the issuance of greenback monies as full legal tender (to mitigate or eradicate the speculative deflationary practices that hurt farmers)—equated fencing with monopolization and suggested that most of the big ranches and their outside backers were bent on reducing itinerant cattlemen, small stockmen and farmers to feudal serfs. The message rang true for many Texans.

With no small amount of public support, the fence-cutting crusade evolved into what became known as the Fence-Cutters' War, and saboteurs began leaving cautionary notes, often containing complaints or socio-political statements.

After miles of fence were cut in Coleman County in 1883, the following note—described by the November 4 edition of the *Fort Worth Daily Gazette*

as "A Nihilistic Manifesto"—was found: "Down with monopolies! They can't exist in Texas and especially Coleman County. Away with your foreign capitalists! The range and soil of Texas belongs to the heroes of the South."

An earlier note (reported in the *Galveston Daily News* on August 9) accompanying a fence-cutting effort in Hopkins County (250 miles away in East Texas) concurred: "We don't care to be made serfs of yet like poor Ireland and the majority of England. We are a free people and if we can't have protection, we'll protect ourselves."

In other cases, practicality was as important as principle. When Bart and Luke Moore fenced in a water source nine miles south of Waco, a fence-cutting group calling themselves the Owls burned some of the enclosed pastures, cut up substantial stretches of barbed wire and made the following demand: "You are ordered not to fence in the Jones tank, as it is a public tank and is the only water there is for stock on this range. Until people can have time to build tanks and catch water, this shouldn't be fenced."

In some areas, if ranchers who installed barbed wire had the common sense or courtesy to include a gate or two here and there (so folks didn't have to travel an additional twenty miles out of their way to go to town or get access to water), their fences were spared—but not always. A Tennessean rancher who owned a spread encompassing both the Turkey and Bear Creeks just outside Aledo (in Parker County) had his fence cut despite having five gates. He promptly rebuilt it, and the fence cutters struck again, this time pulling up the posts and leaving a wry note: "We understand that you have plenty of money to build fences. Please put them up again for us to cut them down again."

In Live Oak County, seventy miles south of San Antonio, fence cutters grounded a fence line and dug a mock grave, complete with a makeshift headboard that read, "This will be your end if you rebuild this fence."

In many cases, the fence-cutting activities were surprisingly efficient and well organized, including armed lookouts to protect the participants as they cut the barbed wire. They usually worked at night but occasionally appeared during the day. Sometimes they blacked their faces and wore costumes.

In 1883, the fence-cutter imbroglio figuratively and perhaps literally reached a boiling point. Texas suffered a horrendous drought. Cattle died in droves on the dwindling, open, common ranges, and the effect of closed range areas was catastrophic for landless stockmen. Some closed-range rancher advocates even grazed their cattle on the open ranges until the grass was gone and then moved them into their enclosed pastures. This

exacerbated the situation, increased fence cutting and pasture burning and infrequently led to sizable herd liberations, if not outright theft.

Ranchers began hiring security personnel to patrol their fencing. One large ranch in De Witt County even persuaded some Texas Rangers to trade in their tin stars for fence security work, and confrontations along the barbed-wire boundaries increased, resulting in several casualties.

By late 1883, newspapers were reporting that losses from destroyed fencing reached $20 million and tax valuations in general had declined by approximately $30 million. These were staggering numbers, and they began to shift public opinion. Also, in the beginning, the wide-scale fence-cutting subculture was viewed as a reasonable form of civil disobedience, but like many fair-minded protest efforts that were originally committed to addressing inequities, the fence-cutting activities intermittently devolved into petty or pointless swipes that approached vandalism, anarchy or counter-opportunism instead of redress.

With public opinion starting to favor the fencing interests, Texas politicians mustered resolve. On October 15, 1883, Governor John Ireland scheduled a special session of the Texas legislature (set for January 9, 1884) "to consider and find remedy for wanton destruction of fences, to provide a more efficient system of highways and to amend the law providing for enclosing school lands."

After weeks of heated debate, the special legislature adjourned with new laws on the books. Fencing the land of another led to a misdemeanor, a fine not to exceed $200 and the culprits being granted six months to remove the illegal fence line. If the fence ran across public roads, fencers were required to install a gate every three miles and make sure the gates were kept in working order.

Injuring a fence or leaving a fence gate open (causing "any hogs, cattle, mules, horses or other stock to go within the enclosed lands" and graze without the consent of the owner) led to a fine of $10 to $100 and imprisonment for up to one year. Willfully cutting a fence led to a felony and imprisonment of "not less than one nor more than five years." And pasture burning, also deemed a felony, resulted in a two- to five-year imprisonment.

Enforcement of the new laws drastically reduced fence-cutting offenses, but they didn't end altogether, and indignant contrarians remained. A letter to the *San Antonio Express* in 1884 reaffirmed a common sentiment: "I fought thru the so cald sivel war for the property of the ritch men and now some of Blue Bellys own large tracks."

In the summer of 1888, fence cutting became a regular occurrence in Navarro County, and the Texas Rangers headquarters in Austin dispatched Sergeant Ira Aten and Jim King to help. Aten and King posed as farmhands and became familiar with the local fence cutters but got creative instead of

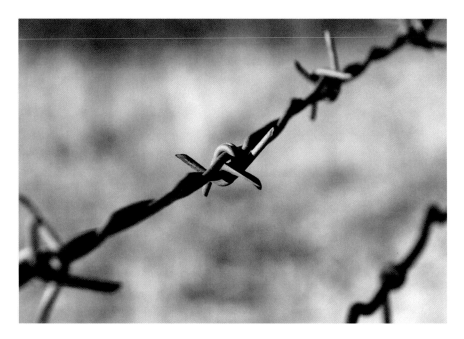

Barbed-wire fence, the true tamer of Texas. *Photo by Jon "ShakataGaNai" Davis.*

arresting them. Aten purchased dynamite and put together late nineteenth-century IEDs (improvised explosive device) designed to be triggered by barbed-wire strand severance. When Aten's superiors got wind of his plan, he was ordered to stand down and return to Austin, but rumors of the fence-line IEDs were enough to eliminate fence cutting in the area.

In 1898, a Brown County fence-cutting group known as the White Cappers severed fence after fence and threatened to poison livestock and dynamite houses if fences were rebuilt. In one instance, they even approached a fence-repairing party in broad daylight and threatened them at gunpoint.

Ultimately, the fence cutters won a few battles but lost the war. Easy access to railroad cattle cars made long cattle drives unnecessary and free grazing anathema. Soon, the big ranches genuinely didn't have a "use for the long horn cow" (whose trail durability was legendary) and had less use for cowboys. Fenced pastures reduced rustling and limited herd mobility; fewer hands were necessary.

The era of "old Texas" passed quietly, and frontier purists took their horses "and hit the trail upon a lope," heading south to Mexico or west for the waning stretches of open American range.

There was, however, one intriguing postscript.

During the 1880s, the Texas Panhandle and the South Plains area of west Texas got a little too crowded with ranches and livestock. As the region was notoriously vulnerable to powerful Blue Northers—frigid storm systems that moved over the land, dropping temperatures rapidly, bringing hard freezes and creating blizzards—the cattle there had gotten into the habit of drifting up to one hundred miles south to take cover in draws, canyons and river valleys. Every time a Norther blew through, the cattle dispersed, and the ranchers had a hard time gathering and regrouping their herds.

In 1882, with barbed wire all the rage, the Panhandle Stock Association decided to build a "drift" fence to keep northern livestock from drifting down to the southern ranges. Within a few years, the fence stretched the entire length of the Panhandle, from New Mexico to Oklahoma.

In 1885, a powerful blizzard season sent the northern cattle south, and they got stuck at the new fence. The cattle converged at the barrier in increasing numbers, cold, jammed up and bogged down. Those that weren't trampled or smothered froze or starved to death where they stood or fell easy prey to wolves and coyotes. The first thaw of January 1886 revealed a bovine deathtrap. Thousands of cattle lay dead along the fence line, and several big ranch herds were almost destroyed.

Legendary Seven K Ranch foreman Frank Biggers was so incensed by the unnecessary losses caused by what came to be known as the "Big Die Up" that he demanded the Seven K Ranch owners allow him to cut the Panhandle fence, but they refused. Biggers immediately quit and wired his resignation from the location of his new employer, the Box T Ranch.

The 1886–87 winter brought more of the same, and cattle once again perished by the thousands. One ranch hand reportedly skinned 250 carcasses a mile for approximately thirty-five miles along one stretch of drift fence.

LAKE WORTH MONSTER

In late June 1969, the Fort Worth police began receiving reports about something frightening folks around Lake Worth. The accounts were odd, and the police basically laughed them off as pranks.

Then, just after midnight on July 10, John Reichart, his wife and two other couples were attacked as they sat in a parked car near Greer Island. Something leapt onto their vehicle from a nearby tree and tried to grab Reichart's wife. Reichart started his car and sped away before it could try again. The terrified couples immediately contacted the police.

Four police units responded to the Reicharts' call and inspected the site of the attack. They found nothing except an eighteen-inch scratch down the side of the Reicharts' car that every witness claimed was caused by the creature's grasping claw. The victims described their attacker as "part man and part goat" and claimed it had been covered with fur and scales. The police again suspected some kind of prank but performed a serious investigation anyway because (as patrolman James S. McGee observed) the Reicharts and their friends were genuinely shaken up.

Later in the day, the July 10 afternoon addition of the *Fort Worth Star-Telegram* featured a front-page story on the thing that had attacked the Reicharts. The headline stated "Fishy Man-Goat Terrifies Couples Parked at Lake Worth." The reporting took on a life of its own, and by late afternoon,

there was related television and radio coverage. News of the incident was discussed in every household, and by midnight, several carloads of people had gathered in and around the Greer Island Refuge and Nature Center to see the "Lake Worth Monster" themselves.

They were not disappointed.

After being spotted just off a park road, the creature appeared on a high bluff near the lake. There were thirty to forty spectators, including members of the Tarrant County Sheriff's Department. According to eyewitness accounts, the creature howled as it moved along the edge of the bluff and became agitated, hurling a spare tire approximately five hundred feet toward the crowd. When the radial landed in the vicinity of the onlookers, everyone—including the sheriff's deputies—jumped into their cars and abandoned the scene.

The next day, the *Star-Telegram* ran another front-page story that read "Police, Residents Observe But Can't Identify 'Monster.'" The account was accompanied by a photo of the bluff from which the creature was seen hurling the spare tire. In the foreground, witnesses Jack Harris and Ronnie Armstong stood next to the tire; in the background, the *Star-Telegram* art department superimposed a dashed line indicating the tire's trajectory.

Harris confirmed earlier reports, noting that the creature walked like a man but didn't look like one. "He was whitish-gray and hairy," Harris said. "I might have been scared, but he looked like he was 7 feet tall and must have weighed about 300 pounds." Harris described the creature's howl as a "pitiful cry, like something was hurting him." He had tried to take a picture of the "monster," but his flash didn't work.

Sergeant A.J. Hudson, the officer who investigated the sighting, said he wasn't worried so much about the creature as he was about the small mob pursuing it. Apparently, some of the monster hunters had been carrying guns, and Hudson was afraid someone would get hurt.

Jim Marrs, the original *Star-Telegram* reporter on the story, attempted to shed light on the sightings by soliciting the opinions of two local experts. Helmuth Naumer, the curator of the Fort Worth Museum of Science and History, said the creature was probably a cat. Richard Pratt, a naturalist in charge of Greer Island Refuge and Nature Center (now known as the Fort Worth Nature Center and Refuge), concurred. Pratt said someone had previously released a pet bobcat in the park and it might be responsible for the reports, especially since the cat liked people and might be accustomed to sitting in tree branches.

In the early hours of July 12, carloads of curiosity seekers once again descended on the Greer Island Refuge and Nature Center hoping to catch

a glimpse of the creature, but this time they had no luck. The monster was a no-show, and the police were relieved. The *Star-Telegram* printed a short blurb entitled "Whatsit Takes Night Off," but the police were still concerned that somebody might accidentally get shot.

The next day, Tarrant County sheriff Lon Evans told the *Dallas Morning News* that he didn't think the creature existed. "There may have been a prankster going around out there dressed up like some kind of monster," he said. "If he is, it's a good way to get shot."

Evans also teased a theory approaching Freud's notion of a communal neurosis. "There's also the possibility that some people have hypnotized themselves," Evans said. "And they're convinced that they saw some kind of apparition."

For the next few days, interested parties continued to cruise around Greer Island after midnight looking for the creature, but they saw neither hide nor hair (nor scale) of it.

On July 14, the *Star-Telegram* featured a short "Tarrant Today" brief entitled "Ghosts Seen on Greer Island." The author, Jim W. Jones, reported that a Fort Worth resident named Mike Kinson had—in addition to seeing the Lake Worth monster—also witnessed apparitions that appeared in a mysterious mist. Kinson claimed the ghosts were "see-through" but perceptible. "It's hard to explain," Kinson said, "and I know it sounds crazy. We thought it was some kind of trick at first."

Kinson indicated that he and others had encountered the monster and the ghosts on several occasions but only when visitors were sparse and the park was quiet. When Jones asked Kinson how the ghosts responded when they were spotted, Kinson said he and his companions never "stuck around long enough to find out."

A few days after the July 10 sightings, a local artist named Joe Pack came forward with a sculpture of the creature that he had created after listening to the details he had gathered from eyewitness accounts. The *Star-Telegram* ran a short story and an accompanying photo of Pack and the plaster rendering on July 17.

On July 18, the creature made the *Star-Telegram* editorial page. In a piece entitled "Lake Worth Monster a Jolly Good Sport," a newspaper staffer relegated it to a paranormal phylum of "sportive apparitions" whose "purpose is to amaze, sometimes shock, but seldom to cause lasting anguish." And, as for proof of the creature's existence, the article noted that "the Loch Ness monster has existed for generations on evidence neither so well-documented nor half so entertaining."

Depiction of the Lake Worth monster by the author.

The creature's trail grew cold after Jones's "Tarrant Today" mention, and it didn't reappear again for almost four months.

On November 7, Charles Buchanan reported that the creature attacked him while he was asleep in a sleeping bag in the back of his truck in the hills across from Greer Island. Buchanan claimed he made his escape by pushing a bag of chicken toward the beast, which it promptly stuffed in its mouth before returning to the lake and swimming back to the island.

After the Buchanan sighting, which seemed fishy in its own right, the monster seemed to take a hiatus. When local boys fighting in Vietnam got wind of the Lake Worth monster coverage, they often acquired about it in letters, but all the newspaper headlines were soon dominated by U.S. astronauts landing on the moon. The story died out for everyone except Fort Worth resident Sallie Ann Clarke.

In late 1969, Clarke self-published a 119-page book on the subject, entitled *The Lake Worth Monster of Greer Island*. In it, she provided several eyewitness accounts, photos identifying witnesses, last known whereabouts of the creature and many of the aforementioned newspaper clips. Ronnie Armstrong reemerged and figured prominently in an amateur investigation indicating that the creature had been wounded at some point, and one photo depicted Armstrong identifying a blood sample taken from a pool of blood and blood splatters leading to the water's edge. The caption below the photo claims that several large tracks were also found in the area and that Armstrong and Clarke believed they belonged to the creature. Another photo identified Fort Worth resident Gary Stanford and several teenagers from Diamond Hill, noting that the boys had originally referred to the creature as the "Mud Monster" and that they'd been chasing it for years.

Clarke's book received little serious attention, and the story seemed to end. The creature wasn't seen or heard from again until 1973, when it appeared to "pond" jump. On the evening of March 13, Mark Fricke, a nineteen-year-old security officer at Carswell Air Force Base, was approached by a seven-foot-tall "big black creature which looked like a large bear" at Benbrook Lake—fifteen miles away from Lake Worth. Fricke had been relaxing at Holiday Park, listening to music and enjoying a soft drink. He claimed he heard a strange howl and turned to see an unidentifiable creature splash through the shallows and disappear in the surrounding brush.

Fricke phoned the Benbrook Police Department, and they responded with a search party, but no trace of the creature was ever found. Local newspapers wondered if the local "lake monster" had returned from hibernation.

After the Benbrook sighting, the Lake Worth monster—prankster, bobcat, bear, apparition, goat-man, satyr or North Texas "whatsit"—disappeared into the pages of local lore.

Today, bigfoot enthusiasts list it as a veritable case study in the existence of modern cryptids, but the monster only haunts campers through the ghost stories told at summer camps around Lake Worth.

BONHAM ECCENTRIC

In the early 1840s, a land surveyor named Tom Bean moved to Bonham. He charged twenty-five cents an acre and would only accept payment in acreage. Bean built a one-room, fourteen- by fourteen-foot cabin near the town. He kept to himself and lived a Spartan existence. It was later said that he donned the same plug hat and long black coat for decades.

Bean was soft-spoken and reserved, but everyone in Bonham knew him. He was a respectable gentleman but had few close friends. He gave to every church in the community but declined membership in all. He occasionally made appearances at town balls but neither called on nor courted any Bonham ladies. One newspaper of the period characterized Bean as one "possessed of the noble but rare trait of attending to business." And for the next forty years, business was good.

By the mid-1880s, Bean had reportedly amassed over twenty-five thousand acres in eight counties, including Fannin, Grayson, Cooke and Collin. Some folks claimed that Bean could ride from Bonham to San Antonio by horse and spend every night on his own land. Though one of the wealthiest men in Texas, he still lived in the same one-room cabin. And instead of leasing, cultivating or at least fencing his vast holdings, he kept them available for poor folks to utilize free of charge or encumbrance. In fact, he allowed several African Americans to put up cabins near his and seemed to prefer

their company to the regular townsfolk's. An African American woman named Sukey Byers had her cabin right behind his and worked as his cook and housekeeper. She and her immediate kin were always around the Bean place, and it was clear he considered them extended family.

Bean was never designated persona non grata, but it was obvious that many of the citizens of Bonham considered him odd. To be fair, however, the community's tolerance of his eccentricities was much better than many other Texas towns would have been at the time. Fannin County—like Cooke, Grayson, Lamar and Collin Counties around it—had voted against secession, but the so-called War of Northern Aggression was hardly a generation passed, and most of Texas behaved as perpetually aggrieved as the rest of the former Confederacy.

In 1886, a group of citizens in Comanche expelled every African American living in Comanche County at gunpoint. And from 1886 to 1887 alone, there were almost a dozen African Americans lynched in Texas, some in counties as close as Cooke and Kaufman—and those are just the ones that got reported. Bean's extended family and his communal attitude toward his land would have been frowned upon openly and aggressively in many Texas communities.

On July 24, 1887, Tom Bean passed away surrounded by his extended African American family. Sukey Byers ran through the streets crying.

By July 26, folks began to wonder what would happen to Bean's immense holdings. Fannin County judge E.D. McClellan placed W.W. Russell, Sim Winneler, John Sparks and a Bonham municipal judge on a committee to take charge of the papers belonging to the Bean estate. It was generally believed that Bean had left behind a will, leaving most of his assets to his extended African American family, but the document never surfaced. Also absent was any information regarding when Bean was born, where he had come from and whether or not he had any surviving relatives. All the committee reported finding was a well-worn, musty copy of the Holy Scripture with the ages and birthdays of his African American extended family recorded in it.

Within a month, the story of Bean's heirless fortune was bandied about in conversations along both coasts and from the Great Lakes to the Gulf of Mexico, and Bonham became a mecca for the litigious. As the *Galveston Daily News* described it, "Claims were filed and the lawyers smiled sweetly…like vultures watching their victims."

On September 23, 1887, a Louisianan named James W. Saunders appeared in Bonham claiming to be Bean's younger brother. He said Bean had changed his name after killing a man named "Crutchfield" in Tennessee

and asserted that Bean had lived as a fugitive in Camden and Fayetteville, Arkansas, before settling in Bonham. Saunders also claimed that he himself had visited with Bean in Gainesville and Austin and loaned him money on both occasions.

James Gass, an African American identified as a former slave of Bean's, insisted he had seen Saunders visit with Bean in 1864. A *Galveston Daily News* reporter initially described Gass as "mute as an Egyptian mummy," but Gass eventually loosened up, claiming that he could "prove by prominent white men that Col. Bean had a will" and that "he gave a part of his estate to we darkies."

On October 1, a Colonel M. Leeper of Sherman came forth and claimed to have known Bean, his father, Colmore, and his brothers John and Oscar as far back as when they lived in Fayetteville between 1839 and 1840. Leeper said Bean never mentioned that his name was Saunders or that he had killed a man. "In fact," Leeper added, "I am loath to believe that he would kill anyone." Bean had been to the Leeper residence in Sherman on several occasions, so Colonel Leeper's opinion held great weight.

The first hearing regarding the future of the Bean estate occurred in Fannin County Court on November 29, 1887. H.P. Howard of San Antonio filed a motion for executorship of the estate, based on a plea of direct kinship. Howard claimed to be the grandson of Colmore Bean's brother John. Howard's attorney stated that Bean's identity could be established as far back as 1836, and this demonstration rendered Saunders's claims of murder and flight ludicrous. Saunders argued that there was no need for an executorship (because the estate was only minutely indebted) and that the matter should proceed directly to district court to determine "heirship." W.W. Russell, a member of the current committee serving as executor of the estate, pleaded for an extension of his executorship. And Sarah A. Dove, recently arrived from Washington, D.C., watched on quietly with her attorney, W.W. Walton.

On the second day of court proceedings, and to the surprise of many, counsel for H.P. Howard introduced a packet of letters discovered at the Bean cabin, chronicling correspondence among Bean, his father and his brothers from 1842 to 1846. How this packet had escaped Judge McClellan's preliminary committee for the estate was never quite explained, but it clearly gave Howard the upper hand. The packet of letters included an 1832 correspondence from B.F. Landers (of Fayetteville) to Bean, relating the news of Oscar Bean's demise while en route to California; and an 1833 letter from W.B. Smith of California, describing the circumstances of Bean's brother John's death due to the accidental discharge of his own firearm.

After Howard's attorney presented Bean's personal correspondences, counsel for W.W. Russell introduced witnesses for rebuttal. A former Fannin County district clerk named Blair was sworn in and presented election records of 1870 that indicated that Bean listed his sworn age as forty-eight. Russell also took the witness stand, testifying that despite what Howard's counsel had submitted, no papers found at the Bean residence traced his identity as far back as 1836.

Next, counsel for Russell introduced a September 16, 1873 correspondence from Howard to Bean. In it, Howard asserts a possible relationship between himself and Bean, noting that his mother Nancy's maiden name was Bean and that she had two brothers, George and Thomas Bean. Russell's attorney summoned a local Bonham doctor named Penwell to the stand, and Penwell testified that when Bean received the letter, he dismissed the suggestion as poppycock. A witness named John Galbraith also took the stand, corroborating Penwell's testimony and claiming that Bean told him he had no living relatives. Finally, an ex-senator named Grace was sworn in and said that he had known Bean for twenty years and never heard him tell of any relatives.

As the H.P. Howard interest arrived in possession of Bean's personal correspondences, the Fannin County court found that Howard presented the strongest case for executorship of the estate. Russell appealed the case to the district court, and the appeal was scheduled to be heard in February 1888. In the meantime, a Sherman legal firm known as Brown and Bliss filed a petition for the probating of a copy of a will alleged to have been penned by Bean and lost, destroyed or "taken possession of by some unauthorized person" after Bean's death.

The probate request denied the familial claims of H.P. Howard, Sarah A. Dove and J.W. Saunders and claimed that Bean was of sound mind at the time of his death and authored a last will and testament, which he showed to at least one witness. The missing will, re-created by attorneys of Brown and Bliss and one of the citizens who read the original documents, distributed the estate among those purportedly closest to Bean. It left Bean's extended African American family (Sukey Byers, John C. Watson, Andrew Byers and Tom Byers) four tracts of land near Bonham, totaling approximately 2,000 acres, and all the livestock and farming utensils. It left the Galbraith family, who were good friends of Bean's, $26,060 in cash, several Fannin County tracts of land approximating 1,340 acres and other land parcels valued at $30,000. And it left Kate Knight Edwards and Bell Shortridge, both daughters of Bean's deceased friend William H. Hunt, lands valued at $15,000 each.

Attached to the will was a sworn affidavit of well-known Bean friend and Bowie County farmer John T. Butler, who had reportedly seen Bean's handwritten last will and testament and attested to the instructions and sentiments expressed in the Brown and Bliss recreation.

The Fannin County Court threw out the Brown and Bliss probate request, and legal maneuvers regarding the heirship of the Bean estate began to pick up steam. Some claimants insisted Bean was an assumed name; others alleged they were his illegitimate offspring, his long lost this, his long lost that, etc., etc. Sarah A. Dove fell under one of the latter two categories, and her lawyer wasted no time making sure she was at the front of the line.

On September 19, 1888, the Howard and Dove interests both introduced numerous affidavits that demonstrated that Bean was not an assumed name. On September 21, J.W. Saunders took the stand and said when he visited his alleged brother Tom Bean at his home, he recalled seeing Sukey Byers because he specifically remembered seeing her partially crippled hand when she served him and his brother foodstuffs at Bean's table. On September 22, Sukey Byers took the stand and testified that she had never seen nor heard of J.W. Saunders before Bean's death.

The proceedings dragged on, the claimants smelled wealth and the lawyers grew wealthier encouraging every olfactory impulse.

On November 25, 1891, the *Dallas Morning News* reported that an attorney from Maryland appeared in Bonham, alleging that Bean had an illegitimate child resulting from an "alliance" with a Maryland woman in his youth and that Bean's heretofore unknown offspring was the legitimate heir of his estate. The *News* reporter also noted that while the "litigations continue thousands of acres of the finest lands in north Texas are compelled to be idle waiting the final decision of the courts."

On February 27, 1892, the *Dallas Morning News* reported that when the Bean case reconvened in a Fannin County district court, the petitioners were so numerous that the presiding judge ruled them to costs, and this forced the continuance of the case to be postponed until the next term of court. The *News* article also suggested that there was an increasing sense that the State of Texas might intervene and become a claimant of the Bean estate.

On June 28, 1892, an Illinois attorney named F.T. Crammett announced that he would represent a group of Maine claimants to the Bean estate and that his clients championed the supposition that Bean never had a female sibling and therefore couldn't be a relative to a large number of the current claimants who based their claim on being related to a fictitious sister. The Maine claimants asserted that the progenitor of the estate's real name was Thomas Chelsey Bean,

that he grew up lumbering in the Kennebec woods and made his way to Texas after working on a coasting vessel in the Boston area.

On June 29, 1892, several developments came to light. First, H.P. Howard's executorship of the Bean property paid J.W. Saunders $25,000 to cease and desist in his claims to the estate. Second, the Howard executorship and the Sarah A. Dove interest—occasionally allies in the effort to dissuade J.W. Saunders—were now the chief opposing interests in the litigation, as evidenced by the style of the suit: *Sarah A. Dove et al v. H.P. Howard et al.* To date, there had already been 153 claimants, including plaintiffs, defendants and intervening parties. And under the new *Sarah A. Dove et al v. H.P. Howard et al*, there had already been 8 interpleaders setting up independent claims of heirship and contesting the claims of all other petitioners.

Third, in the midst of all this contention, Dudley Galbraith and J.C. Baldwin, of Haskell, discovered that one 740-acre Fannin County parcel of Bean's contested estate had a defective title. They filed a new title, seized the land and fenced it immediately.

And fourth, John and Mary J. Musgrove, of Dent County, Missouri, filed a suit in the district court of Fannin County, asserting that Mary J. Musgrove was another "only child and heir" of Tom Bean and therefore the Bean estate. The couple, like so many others before them, similarly vowed to present uncontestable proof.

On August 20, 1892, a Kerr County resident named D. McMillen arrived in Bonham and announced that Tom Bean had visited Austin two years prior and composed a will, giving his entire estate to the widows and orphans home of Texas. On the same day, Judge McClellan announced that the Bean case would be postponed for the present and that there would probably be a special session to address it during the upcoming fall.

On November 1, 1892, a special term of the Fannin County District Court convened, with Judge M.H. Garnett (of McKinney) presiding, to announce that the Bean case would be transferred to Grayson County for the final trial. On December 6, a motion was introduced in the new Sherman County Tom Bean probate case to reconsider the change of venue, but it was overruled, and the proceedings were recessed until the following March.

Russell quietly lost his appeal for executorship, and the litigation remained focused on heirship. On January 13, 1896, council for *Sarah A. Dove et al* asked for a division of the Bean estate. An attorney for a new collection of claimants from Topeka, Kansas, made application to intervene. The counsel for the Musgrove interest requested time to file exceptions to the Topeka application, and the court granted a recess. Later, the court reconvened, and

the Musgrove party filed a motion to quash the depositions of numerous Dove witnesses because they were recorded in the offices of an attorney in Tennessee who represented a different client. Dove's counsel pointed out that a full court term had lapsed since the depositions were filed and the motion to quash, so it was too late. The presiding judge agreed.

On January 20, 1896, the depositions of Mrs. Anne Young, a relative of Howard, indicated that both Howard's mother and Sarah A. Dove were daughters of one of Colmore Bean's brothers.

On January 25, 1896, a jury for the district court of Grayson County ruled in favor of Sarah A. Dove et al, declaring them to be the sole heirs of the Tom Bean estate. Commissioners were appointed to manage partition, and on July 17, 1896, the estate was partitioned and distributed.

The court findings did not stem the proceedings.

On August 4, 1897, a new St. Louis claimant named Amanda Marmaduke interceded, alleging that she was Bean's illegitimate daughter.

Around the turn of the century, the Sarah A. Dove et al interest filed suit against the H.P. Howard et al executorship interest, apparently alleging mismanagement or misallocation of the Bean estate assets, and the ongoing squabble inspired American writer O. Henry to lampoon the proceedings in a short story spoof entitled "Fickle Fortune."

For decades, claimants continued to appear, introducing continuations, fresh disputations, inter-pleadings, requests for judgment dismissals, etc. By 1920, the Grayson County courts began requiring $5,000 bonds to even have litigation involving the Bean estate revisited or reopened. In 1938, the state reportedly stepped in and assumed control of whatever parts of the estate were still in dispute.

In the end, every parcel of Bean's immense holdings was sold or claimed or leased and fenced, and his extended family was apparently disenfranchised. A gaggle of strangers Bean had no interest in or affection for meted out his life's work to a broader gaggle of strangers he had no interest in or affection for.

Today, the only evidence of Tom Bean's life and times is a town named after him in Grayson County. Shortly before his death, he donated fifty acres in southeast Grayson County for a new stretch of railroad from Sherman to Commerce. His namesake community sprang up along the new railroad branch, and though he'd never been there and probably wouldn't have been comfortable with having a town named after him, curious folks and supposed long-lost relatives still show up there looking for the Bonham eccentric.

PORVENIR MASSACRE

Porvenir, a small town in the northwestern-most corner of Presidio County, is no longer on most Texas maps. Located in a desolate no-man's land between the Vieja Mountains and the Rio Grande, it never got very big, but size and isolated geography weren't the only factors that led to its disappearance. Porvenir's demise was also helped along by the Texas Rangers.

In 1913, Porvenir—which means "the future" in Spanish—sprang up near the banks of the Rio Grande, some twenty-three miles southwest of Valentine. The area was rugged and inhospitable, but the citizens of the town were extending an irrigation channel from the Rio and the community had high hopes or, as the nomenclature of the town indicated, a future. Within a few years, approximately 150 folks called Porvenir home, and the community had its own cotton gin and a few businesses.

On Christmas Day 1917, however, everything changed. Bandits raided the Brite Ranch near Marfa (in northeast Presidio County), stealing horses, robbing the ranch store and killing a few ranch hands. Local American cavalrymen under the command of Colonel George T. Langhorne chased the bandits back into Mexico, reportedly killing eighteen before they scattered into the foothills of the Occidental Sierra Madres.

Preliminary reports of the raid ranged from the usual to the outright fantastical. The United States was already involved in World War I, and some

newspapers, including the December 28 edition of the *Dallas Morning News*, reported that the Brite assault might actually have been a siege conducted by the Germans. But none of the Kaiser's troops were ever killed, captured or seen for sure, so the search for the culprits reverted to the usual suspects, i.e., Mexicans (or Hispanics in general).

Texas-Mexico relations along the border had been strained since the Mexican Revolution and Pancho Villa's 1916 raids on Glenn Springs (in the Big Bend area) and Columbus, New Mexico. But Texans were also apprehensive about rogue outliers in the military of Mexican president Venustiano Carranza and marauders affiliated with a Mexican Robin Hood–like bandit known as Chico Cano. Ranchers in the area had had enough, and they vigorously expressed their dissatisfaction to Texas Ranger captain J.M. Fox, of Marfa. The aggrieved parties and Fox believed that the bandit problem in Presidio County could be traced to Porvenir and that the small community served as either a hideout or a way station for troublemakers.

On January 23, 1918, Captain Fox; local ranchers John Pool, Buck Pool, Raymond Fitzgerald and Tom Snyder; and Texas Ranger Company B visited Porvenir. They encircled the town and conducted a search for stolen articles from the Brite Ranch. They encountered no resistance, but the Ranger posse discovered some toiletries, sandals and other incidentals that may have come from the Brite Ranch store. The Rangers were unable to determine whether the items were procured legally or illegally, but they decided to disarm the entire town anyway.

The Porvenir disarmament amounted to one pistol (found in the home of the cotton gin owner, the only Anglo citizen in the community) and one Winchester rifle. The posse confiscated the arms and took three Hispanics into custody for questioning. They released the suspicious parties the following day.

On January 26, Captain Fox, the ranchers and a thirty-man Ranger posse showed up at Camp Evetts, an Eighth Cavalry outpost located four miles from Porvenir. They carried a letter from Colonel Langhorne instructing Camp Evetts commanding officer Captain Harry H. Anderson to assist Captain Fox.

Anderson's forces had already investigated the Brite Ranch raid on their own and determined that the residents of Porvenir had nothing to do with it. When Captain Fox and his rancher advisors insisted that a number of Porvenir citizens were either the Brite raid culprits or involved with the Brite raid culprits, Captain Anderson and his men were skeptical, but orders were orders. Captain Fox informed Captain Anderson of rumors that suggested a

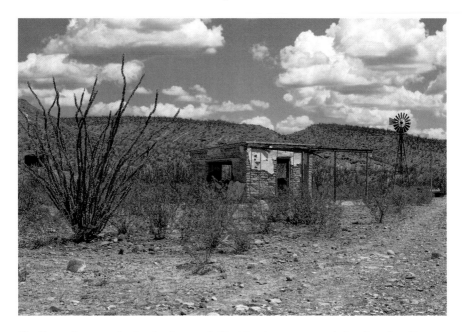

The Porvenir area today is a landscape of dilapidated structures and abandoned mailboxes. *Photo by Derrick Lee Perrin.*

midnight appearance of bandits in Porvenir, so Anderson sent eleven of his command with Fox for a late-night investigation.

When the joint force reached Porvenir in the wee hours of the morn, the Eighth Cavalry contingent secured the perimeter and the Ranger posse went door to door, ordering the inhabitants of the community out of their homes. The Ranger posse then took custody of the only fifteen able-bodied Hispanic men in the community and began marching them down a river road outside the town. The Eighth Cavalry contingent followed them as far as the turnoff for Camp Evetts. When the cavalry was gone, the Ranger posse lined the unarmed Hispanics up in front of the nearest bluff and gunned them down in cold blood.

When news of the slaughter reached Camp Evetts the following morning, the Eighth Cavalry returned to Porvenir and helped the Hispanic women and children of Porvenir collect the bodies. The dead included (ages approximate): forty-four-year-old married father of three Longino Flores; thirty-five-year-old married father of three Alberto Garcia; thirty-seven-year-old married father of nine Eutimio Gonzalez; twenty-five-year-old Pedro Guerra, who had only been in Porvenir for a few days; fifteen-year-old Severiano Herrera and twenty-three-year-old Viviano Herrera, both

only having been in town for ten days; thirty-year-old married father of four Macedonio Huertas; fifty-year-old married father of six Tiburcio Jaquez; sixteen-year-old Juan Jiminez; twenty-seven-year-old Pedro Jiminez; twenty-five-year-old Zarapio Jiminez; forty-seven-year-old married father of seven Manuel Morales, whose seventh child was born the night he was murdered; Roman Nieves, married father of six at the time of his murder—his seventh child was born three months after; Antonio Castamudo, who, like the Herreras, had only been in town about ten days; and Ambrosio Hernandez, married father of one.

Captain Fox and the Ranger posse immediately denied any wrongdoing, claiming they had been fired upon by their captives' accomplices and that the captives themselves had perished in the ensuing crossfire. In a February 18 letter to Adjutant General James A. Harley, Fox even suggested that he had been completely unaware of the Porvenir casualties until Colonel Langhorne reported them to him on January 28. Colonel Langhorne vouched for Fox's version of the incident, but Captain Anderson demurred.

The bodies that the Eighth Cavalry and the nine new Porvenir widows discovered the day after the incident showed evidence of torture and mutilation, and Captain Anderson characterized the Ranger report as "white-washed." Also problematic for the Ranger account was a written report submitted by Henry Warren, a Presidio County schoolteacher and Anglo son-in-law of Tiburcio Jaquez. Warren arrived in Porvenir shortly after receiving news of the incident and unequivocally termed it a massacre, recording some of the only details and biographical data that remain in existence today.

None of the Texas Rangers or private citizens involved in the slaughter was ever indicted by a Presidio grand jury, and most of the Porvenir survivors took the remains of their husbands, fathers, brothers and sons to Mexico for interment and never returned. They were afraid the Ranger posse might come back to finish them off.

The town of Porvenir never recovered. It teetered on for another couple of decades or so, even receiving a post office in 1926, but by the 1940s, it was nothing more than a dilapidated village. In 1948, the post office closed, and by the 1970s, rural doctors would visit the last remnants of the community once or twice a year by plane.

In the end, the town of "the future" wasn't the only thing the Porvenir Massacre finished off. Captain Anderson went on to insist that Governor William P. Hobby remove the Ranger presence in the region because it was causing more problems than it solved. On June 4, 1918, Adjutant

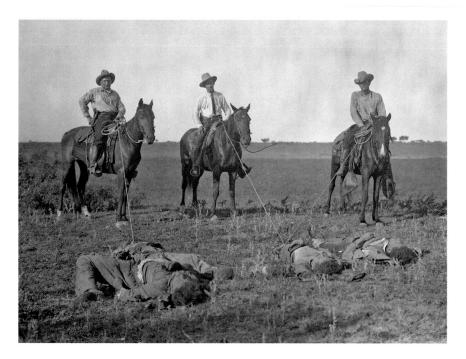

Texas Ranger captain J.M. Fox (left) had a history of "summary justice." These accused Hispanics were shot after a train derailment outside Brownsville, circa 1915. *Photo from the Robert Runyon Photograph Collection, 00097, the Dolph Briscoe Center for American History, the University of Texas at Austin.*

General Harley—by order of Governor Hobby—disbanded Texas Ranger Company B (effective June 8); dismissed Rangers A.C. Barker, Allen Cole, Max Newman, Boone Oliphant and Bud Weaver; and folded the remainder of Company B into Company D, which was headed by Captain Jerry Gray.

Captain Fox was livid and immediately resigned. In his resignation letter to Governor Hobby, he took full responsibility for any alleged misconduct in the Porvenir incident and berated the governor for dismissing his men. But his grievances went further. "Why do you not come clean and say that this is purely politics just to gain some Mexican votes?" Fox wrote.

Fox claimed that he and his men were being unfairly scapegoated and even mustered indignation: "We have stood guard to prevent Mexican bandits from murdering the ranchmen, the women and children along the border while you slept in your feather bed of ease."

On July 3, Adjutant General Harley responded pointedly. "We are not interested in your political views when a question of the honor and decency

of the state is involved," he wrote. "You know, as all peace officers should know, that every man whether he be white or black, yellow or brown, has the Constitutional right to a trial by jury, and that no organized band operating under the laws of this state has the right to constitute itself judge and jury and executioner and shoot men upon provocation when they are helpless and disarmed."

A 1919 investigation of the Texas Ranger presence along the border called for by State Representative Jose Tomas Canales (of Brownsville) determined that the Rangers had been responsible for countless unjust acts in the region during the previous decade and hundreds of murders, mostly of Hispanics. On March 19, the inquiry culminated in the entire ranks of the Texas Rangers being reorganized and reduced.

CAPROCK INCIDENT

On Wednesday, February 3, 1960, Texas Tech University students Kelton R. Conner Jr., John P. Arden and Robert A. Keplinger left Lubbock and drove eighty miles northeast to hike and collect wildlife specimens in an area that was then known as the Caprock, a long stretch of cliff-like bluffs that divides the high and low plains of the Texas Panhandle.

Conner, a native of Dallas, was an avid student of biology and zoology. He had made several trips to the region to explore caves and survey the local canyon ecosystem. He was a transfer from Arlington State College (now UTA), where he had been a member of the ROTC program. Arden was a junior architectural engineering major and a member of the Delta Tau Delta fraternity and the West Texas Sports Car Club. He had spent the previous summer vacation working at Yellowstone National Park. Keplinger was a senior engineering major. Arden and Keplinger were from Waxahachie and both members of the same church, Central Presbyterian. All three young men were twenty-one years of age, healthy and able-bodied.

The weather was mild when they left, and they were looking forward to catching a glimpse of one of the eagles that had been spotted in the area. According to the *Odessa American*, Conner had joked with his roommate, Neil Allen, of Grand Prairie, before he left: "If I don't show up by Thursday," he said, "call my mother—I'll be lying dead in a canyon somewhere."

They were the last words anyone ever heard from them.

Conner, Arden and Keplinger drove to the edge of the Caprock formation and parked their car near the Lemons Ranch, several miles southeast of Silverton. Then they hiked into the canyons, went through the slot-canyon formation known as the Narrows and camped in a cave-like shelter near Linguish Falls.

A winter storm surge arrived that night.

When their automobile had remained unattended for three days, locals grew concerned and searched the immediate vicinity. On Saturday, they found the remnants of the young men's campfire but no sign of them.

Searchers regrouped at first light Sunday morning with help. A dozen horsemen and two jeeps packed with volunteers (directed by Texas Ranger captain Raymond Walters) were joined by a helicopter search team from Reese Air Force Base in Lubbock. They began scouring the area.

Keplinger's body was found first by Jim Brooks of Silverton. Keplinger had apparently lowered himself into a hole several feet deep to keep warm. His body was discovered in a crouching position, one hand clutching a handkerchief. His last refuge was a short distance just across a canyon from the ranch house of C.E. Tipton.

Searchers then found Conner's body a mile and a half to the southeast, just a short distance from the ranch house of John Lemons. Dressed in army fatigues, Conner was lying facedown in a gully under a cedar tree, his arms outstretched and one hand clasping a glove and his glasses. Blinded by the snowstorm, he had apparently stumbled off the edge of a high bluff, fallen into the tree and tumbled to the Caprock floor.

Arden's body was discovered last, almost four hundred feet from Conner's. He had fallen from a towering limestone cliff into a ravine. Arden had apparently been knocked unconscious by the fall's impact and suffered a skull fracture, bruises, lacerations and loss of blood. One of his tennis shoes was still lying at the top of the cliff.

Searchers gathered up the young men's remains and transferred them to the Silverton Funeral Home. Silverton resident and Briscoe County judge J.W. Lyons acted as coroner and ruled that all three deaths had been the result of exposure early on Thursday, February 4.

Investigators concluded that Conner, Arden and Keplinger had been surprised by the winter surge and then trapped and separated by the accompanying blizzard. Keplinger apparently took unsuccessful shelter. Conner and Arden presumably clambered for help or safety and were whipped and blinded by the lashing snowstorm.

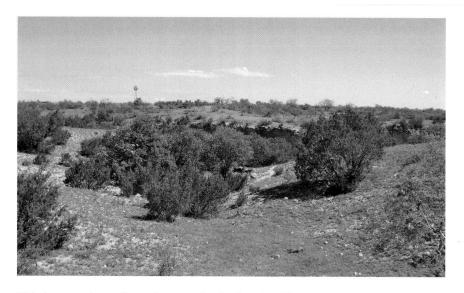

This draw runs into a Caprock canyon that leads to the "Narrows" and Linguish Falls. Kelton R. Conner Jr.'s body was found just inside the canyon area, only a short distance from the ranch house of John Lemons. *Photo by author.*

Conner's joke to Allen turned out to be a grim premonition.

Cold fronts in the Texas Panhandle can come on like a hurricane and drop temperatures forty degrees in an hour. With winds gusting up to sixty miles per hour, they can leave snowdrifts up to a dozen feet high and kill a substantial number of the unprotected livestock in a county.

Silverton resident Jerry Patton was a senior in high school when the accident occurred and, in 2011, recalled the grim search and commented on its grisly results. "Those boys were ill prepared for the weather that can happen in this part of the country," he said. "Their mistake was unfortunately fatal."

Conner's remains were returned to Dallas, and he was buried in Cleburne. The remains of Arden and Keplinger were returned to Waxahachie, where they were laid to rest in separate cemeteries.

The Caprock remained popular with outdoor enthusiasts, and the State of Texas eventually purchased a nearby 15,313.6-acre parcel of ranchland and designated it a public recreation area known as Caprock Canyons State Park and Trailway. The park has precautionary measures in place, and folks interested in hiking and camping in backcountry areas must register with park authorities and list their proposed destination and approximate length of stay in case of emergency, weather-related or otherwise.

HASINAI CADDO

In terms of space and time, the compass and sheer expanse of Texas is difficult for many folks to get their heads around, including Texans. Most perceptions of the state begin with the Spanish claim to it in 1519, but the Spanish—like all European claimants in the Americas—arrived late, and this point is profoundly reiterated at the Caddo Mounds State Historic Site.

Located six miles southwest of Alto, the 397-acre site is the only Caddo mound preserve in the state and features evidence of occupation for over twelve thousand years. After Paleo-Indian (10000–6000 BC) and Archaic (6000 BC—AD 500) habitation for most of this span, a southern Caddo Indian culture known as the Hasinai flourished in the area from 780 to 1260.

Unlike their hunter-gather precedents, the Caddo arrived with highly developed horticultural methods and a fixed, complex culture. Their success and productivity fostered remarkable communities with extensive trade networks (stretching from the Gulf Coast to the Great Lakes), advanced social and political hierarchies and large ceremonial centers. The three mounds preserved at the Caddo Mound State Historic Site are remnants of one such center.

The Burial Mound is over two stories high and inters the remains of eighty to ninety of the Hasinai political and spiritual elite. The High Temple Mound is composed of the remnants of a large, formal, L-shaped pyramidal base upon which temples were built for ceremonial purposes. After each

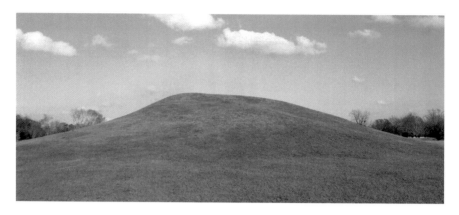

The High Temple Mound at Caddo Mounds State Historic Site. *Photo by author.*

ceremonial cycle, the existing constructions were burned and new ones were built on the ashes of the previous. The Lower Temple Mound was also a pyramidal base structure for ceremonial edifices, but it was only utilized for the last century of Hasinai occupation and therefore never acquired the heights of the Burial or High Temple Mounds.

In addition to the three preserved mounds, the historic complex also includes the remains of a "borrow pit." The borrow pits were human-made depressions created during the construction of the mounds. Year after year and one ceremonial cycle after another, the Caddo transported millions of baskets of soil from the remaining borrow pit and others to create and maintain their burial and temple mounds.

Interspersed among the mounds, the Caddo lived in large beehive-shaped dwellings that averaged forty to fifty feet in height and sixty feet in diameter. Dwelling size and location were based on social rank, and each structure housed an average of two to four families.

In terms of sustenance and security, Caddo men were generally responsible for hunting (deer, wild hogs, turkey, quail, bear and buffalo) and tribal defense, and Caddo women specialized in agriculture (corn, pumpkins, beans, watermelons, squash, sunflowers and tobacco), foraging (nuts, wild fruit, edible roots) and clothes-making.

The supreme deity of the Caddo was Ahahayo, which translates into "Father Above." The Caddo believed Ahahayo was the creator of all things and rewarded good deeds while punishing bad. The chief liaison between Ahahayo and each Caddo community was a spiritual leader known as a Xinesi. The Xinesi presided over Burial Mound interments, blessed crop

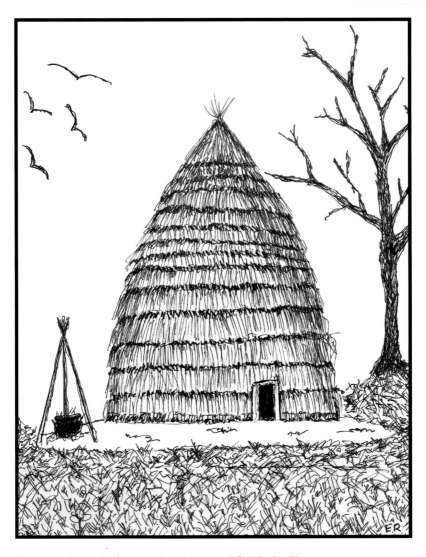

The author's sketch of a large, beehive-shaped Caddo dwelling.

plantings and house constructions and oversaw all other major spiritual matters and feast occasions. Lesser spiritual leaders, known as Connas, presided over common burials and were prolific healers. They made excellent use of the surrounding piney wood forests, which were full of herbs renowned for their curative properties.

The governance of each Caddo community was performed by a Caddi, who in turn utilized four to eight political aides known as Canahas, who, in

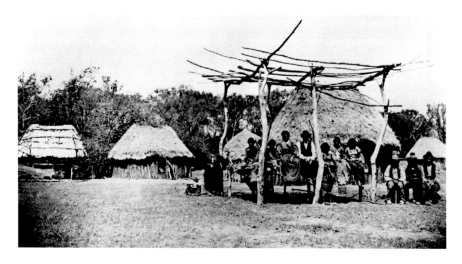

A Caddo village near Anadarko, Oklahoma, circa 1875. *Photo by William S. Soule.*

their turn, had a number of assistants referred to as Chayas to help them. Public assemblies were held in large houses near the residence of the Caddi. Caddo tribal criers, known as Tammas, announced the meetings and generally policed the Caddo people under the direction of the Caddi and Canahas.

The Caddi and his Canahas operated along clearly delineated provisions of authority and kept their communities productive, efficient and motivated. The social order was effective, and Caddo food stores rarely ran low.

Before six European, Mexican and American flags flew over Texas, the Hasinai Caddo throve for almost five hundred years, virtually peerless masters of agriculture, production, exchange, diplomacy and early architecture in the region. They adorned their apparel with elegant ornaments and their bodies with vibrant paint and attractive tattoo art. They created fascinating ceremonial blades and effigies and crafted some of the finest aboriginal ceramics on American soil.

By the time the Spanish met them in the late 1600s, however, the impressive culture had dwindled, leaving only remnants of their presence in scattered farms and villages. They no longer built ceremonial centers or mounds, but one word from their language proved to be their most recognized and long-lasting contribution to the state of Texas. They called the first Spanish explorers they encountered *Tayshas*, or allies and friends. The Spanish later pronounced the word *Tejas* and referred to the area as the Kingdom of Tejas.

JAPANESE BALLOON BOMBS

In the early spring of 1945, the state of Texas was bombed by Japan. Let me repeat that.

In the early spring of 1945, the state of Texas was bombed by Japan.

There were no casualties because the Japanese bomb's payload was lost, probably over the Pacific. In fact, the attack may not have been reported at all if it had not been spotted by a handful of Desdemona teenagers.

On March 23, a fourteen-year-old boy named C.M. Guthery rode a bus home after a day of classes at Desdemona ISD. As he stepped off at his stop, he saw what looked like a massive basketball quickly descending from the sky. He followed it for a moment at a walk and then continued after it at a jog.

Guthery ran almost two miles before the "basketball" touched down, and by the time he got to it, kids from a different bus had already surrounded it. It was an enormous gray balloon with a large, faded "rising sun" illustration near the top.

Several of the children began examining the balloon, snatching guide-rope lengths and pieces of the surprisingly brittle balloon fabric. Guthery hung back. "The thing smelled bad," he told *Texas Almanac* editor Mike Kingston in 1992. "Something like creosote…so I didn't fool with it."

The next day, government officials showed up in Desdemona. They gathered up the remnants of the faulty incendiary at the landing site and

then proceeded to the Desdemona school building to begin collecting the missing pieces.

While government officials were securing the Desdemona bomb, another bomb made landfall northwest near Woodson. That morning, Barny Davis Ranch cowboy Ivan Miller discovered a collapsed balloon—that he would later describe as being as big around as a house—while he was working cattle near his home. Like the Desdemona balloon, the Woodson balloon had a large rising sun depiction near its apex but featured several smaller rising sun images around the bottom.

When news of Miller's find spread, several Woodson-area residents came by to see it and pilfered the landfall area. By the time government officials had finished up in Desdemona, they'd gotten word of the balloon in Woodson and spent the rest of the day there securing the site and gathering all the pieces snatched up by souvenir hunters.

In the cases of both Desdemona and Woodson, the early civilian responders to the balloon landfalls had no idea they had found anything other than big balloons. There were guide ropes and attachment apparatuses in the collapsed balloon skin but no explosives. On May 5, 1945, a group of picnickers in southern Oregon was not so lucky.

That morning, Christian Alliance Church reverend Archie Mitchell drove to the mountains near Bly with his pregnant wife and five young people from his congregation, ages eleven through thirteen. Just before Mitchell got to the picnic area, he dropped his

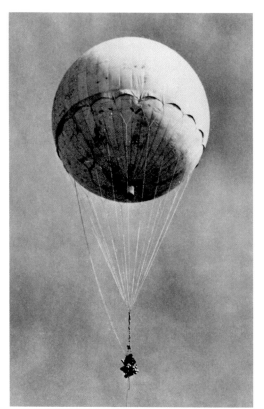

A Japanese "balloon bomb" airborne. *Courtesy of the National Museum of the United States Air Force.*

wife and the kids off so they could hike the rest of the way. After Mitchell parked the car and began transporting picnic cloths and foodstuff to a good shady spot, Mrs. Mitchell and the children called to him indicating they had discovered something resembling a large balloon. Mitchell had been aware of low-key warnings regarding Japanese balloons landing in the area and loudly instructed the rest of the party to stay away from balloon. But it was too late. Mitchell heard a loud explosion and ran toward it. The munitions had killed everyone standing in the immediate vicinity.

The Japanese had begun launching balloon bombs in late 1944 in response to the Doolittle Raid. Between the first and the last day in April 1945, they launched nine thousand balloons, but fewer than one thousand reached the United States. Japan's primary target had been the Pacific Northwest; they envisioned a series of forest fires that might divert manpower and instill fear in the American public.

Each balloon bomb was approximately thirty feet in diameter and seventy feet tall. The balloon itself was initially composed of five layers of paraffin rice paper and filled with hydrogen. Later versions were constructed of latex and fabricated silk. The payload included two incendiary munitions and one thirty-three-pound antipersonnel explosive. The balloons also carried thirty-six sand-filled paper bags that served as ballast. The Japanese launched them up into the jet stream so that the trans-Pacific crossing only took three to five days.

The first balloon bomb discovered stateside was found by two lumberjacks near Kalispell, Montana, in December 1944. Its origin was established by analyzing the sand from one of the balloon's ballast bags, but American officials blacked out all news regarding the Japanese balloon bomb campaign because they didn't want the enemy to be encouraged by confirmed landings or news of casualties. The Oregon picnickers were the only Americans killed by enemy action inside the continental United States during World War II.

QUOTH THE RAVEN

Sam Houston spent the best part of his formative years with the Cherokee Indians in Tennessee. Before he was a warrior, state legislator or governor in the Lone Star or Volunteer States, he was the cherished understudy of a Cherokee chief named Oo-loo-te-ka (also known as John Jolly). In Cherokee, Oo-loo-te-ka's name meant "He Who Puts Away the Drum," characterizing a leader who preferred peace and civility to war and hostility. Houston became fluent in the Cherokee tongue, and the Indians renamed him "Colonneh," which was translated as "the Raven." Ravens were symbols of good luck to the Cherokee.

The Cherokee and Oo-loo-te-ka were profound influences in Houston's life. They informed the way he looked at the world, crafting his cunning and molding his grasp of military strategy. They also shaped his voice, and this is nowhere more obvious than in the winter of 1861.

The Raven had been good luck to Andrew Jackson in 1812; the Raven had been good luck for Texas in 1836. But the Raven had no intention of lending his luck or his loyalty to what he perceived to be the flawed, doomed cause of disunion.

On March 16, Texas governor Sam Houston—easily the most significant figure in Texas history, then and now—sat in the basement of the state capitol in Austin, silently whittling a short length of soft

pine. His fellow state officials were in the main chamber above, awaiting his appearance.

Two days before, the Texas secession convention had voted to require all state officials to swear loyalty to the Confederacy. Governor Houston refused. He was against secession and had no intention of joining the Confederacy.

On February 18, 1861, Governor Houston pled with his constituents in Galveston, somberly warning them:

> *Let me tell you what is coming. Your fathers and husbands, your sons and brothers, will be herded at the point of a bayonet. You may, after the sacrifice of countless millions of treasure and hundreds of thousands of lives, as a bare possibility, win Southern independence…but I doubt it. I tell you that, while I believe with you in the doctrine of state rights, the north is determined to preserve this Union. They are not a fiery, impulsive people as you are, for they live in colder climates. But when they begin to move in a given direction, they move with the steady momentum and perseverance of a mighty avalanche; and what I fear is, they will overwhelm the South.*

Gripped by the pro-secession fervor that had raged for months, rank and file Texans paid Governor Houston little heed. And his fellow politicians foolishly scoffed.

The secretary of the secession convention in the main chamber summoned Governor Houston three times to appear and pledge his loyalty, but Houston kept his basement seat, still whittling. Upon Houston's failure to appear, state officials vacated his governorship. Houston responded with a statement:

> *Fellow-citizens, in the name of your rights and liberties, which I believe have been trampled upon, I refuse to take this oath. In the name of the nationality of Texas, which has been betrayed by the Convention, I refuse to take this oath. In the name of the Constitution of Texas, I refuse to take this oath. In the name of my own conscience and manhood, which this Convention would degrade by dragging me before it, to pander to the malice of my enemies, I refuse to take this oath. I deny the power of this Convention to speak for Texas…I protest…against all acts and doings of this Convention and I declare them null and void.*

President Abraham Lincoln offered Houston substantial military forces to keep Texas from the Confederacy, but Houston declined. He was steadfastly opposed to maintaining his governorship by force. By the time Houston

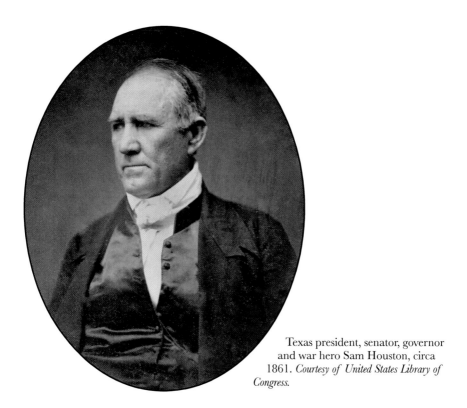

Texas president, senator, governor and war hero Sam Houston, circa 1861. *Courtesy of United States Library of Congress.*

packed up, left the governor's mansion and headed for his place on Galveston Bay, the Confederate flag was already flying over the capitol.

In late March, Houston appeared to speak at the Brenham courthouse at the behest of friends. Several local secessionists jeered and threatened him. A farmer named Hugh McIntyre drew his pistol and cautioned all who those would deny the former Texas president, governor, senator and war hero a say.

Houston, again, delivered an ominous portent: "The soil of our beloved South will drink deep the precious blood of our sons and brethren."

Houston's cryptic warnings went unheeded. Texans turned their backs on their own George Washington and flew headlong into the Civil War.

Sam "Colonneh" Houston lay dying of pneumonia when the decisive battles of Gettysburg and Vicksburg were being waged, but his predictions came to pass. Fathers, husbands, sons and brothers were herded at the point of a bayonet, and Southern soils were sated with the blood of Texans.

VALENTINE EARTHQUAKE

E very February on its namesake holiday, Valentine, Texas, population 131, becomes something of a mecca. Thousands of romantics from around the world send the Valentine postmaster envelopes containing pre-addressed and stamped Valentine's Day greetings so they can be mailed to their loved ones with a handmade Valentine, Texas postmark.

Valentine holds a special place in many Valentine's Day remembrances, but in the early twentieth century, the town was famous for a terrifying breakup—but one that had nothing to do with human hearts.

On August 16, 1931, the most powerful earthquake ever recorded in Texas occurred in Valentine. It started around 5:30 a.m., beginning as a tremble. The tremble lasted seventy-two seconds and turned into a rumble. By the time the rumble resided, the earthquake had damaged every concrete, brick and adobe structure in the town and toppled chimneys all over the area. Wooden structures suffered cracked ceilings and split walls. The schoolhouse structure separated and fell apart. The schoolhouse bell tower collapsed, and fissures appeared in the school yard. Several tombstones shifted and rotated in the local Protestant and Catholic cemeteries. And a huge crack appeared in the earth near the Protestant cemetery. Concrete water tanks cracked and split. Local railroad crews reported tracks appearing to rise slightly and then fall back into place.

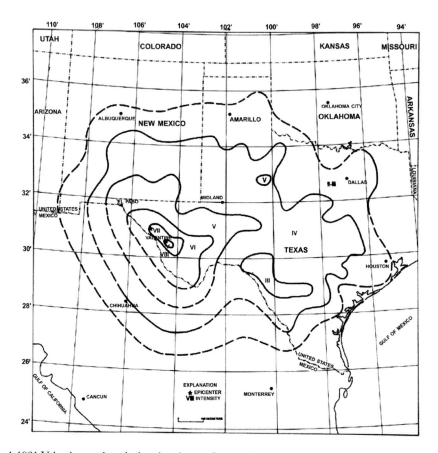

A 1931 Valentine earthquake isoseismal map. *Courtesy of United States Geological Survey (USGS).*

No one was seriously injured, but everyone was affected.

The 5.8 magnitude earthquake measured 6.4 on the Richter Scale, and the damage wasn't limited to Valentine. There were landslides in the Davis, Van Horn, Chisos and Guadelupe Mountains. Plaster fell in Alpine. Houses rocked in Fort Stockton. Buildings swayed in Pecos. Pendulum clocks stopped in Anson. And a two-story hotel in Lobo crumpled.

In San Antonio, dishes were broken and chandeliers swayed. Tremors were felt in El Paso, Del Rio, Dallas (the Balcones Fault, a remnant of a prehistoric quake, stretches from Del Rio to Dallas), Sherman, Bonham, Taylor, Austin, Lockhart and Uvalde. The earthquake was even reported as far away as Oklahoma and St. Louis, Missouri, where they recorded it on a seismograph at St. Louis University.

A 1907 Valentine mercantile building that survived the 1931 earthquake now stands vacant. *Photo by author.*

There were mudslides in Picah, New Mexico, and windows were rattled in Artesia, Carlsbad and Roswell. In Mexico, several people suffered minor injuries in sections of Chihuahua and Coahuila.

In the days following the earthquake, local springs became muddied and folks began finding fish in the area wells and irrigation ditches. Some reliable wells soon declined or dried up altogether.

Like many Texas citizens today concerned about the seismological impact of natural gas extraction "fracking," folks back then wondered if the removal of vast quantities of oil from Texas land might be responsible for the seismic event. But University of Texas geology professor Dr. LeRoy S. Brown dismissed the notion, noting that wherever oil was being extracted, it was being replaced by water. Speaking with the *Dallas Morning News* on August 21, Brown indicated that geologists attributed earth tremors to slips or faults in the earth, not oil removal or water substitution. "In the case of the recent shocks in West and Southwest Texas," he said, "there may have been a weakness in the structure and when the slip or fault occurred, even though it may have been only a fraction of an inch, the surface effects were felt, the severity in any given locality depending on the amount of the slip."

In January 1932, the Valentine School Board received $25,000 in disaster aid from the state and began repairs on the school. Utilizing three-quarter-inch iron rods and turnbuckles below the ceiling joists, they pulled the schoolhouse back together and then installed steel and concrete buttresses on the building exterior to reinforce the turnbuckles. The school bell vanished, and the bell tower was never rebuilt.

Shortly after the earthquake, a local fortune-teller claimed that Valentine would be destroyed by another earthquake the following year. The citizens of Valentine were terrified by a minor tremor on August 16, 1932, but the prediction was incorrect.

On July 19, 1935, Valentine was rocked by another strong seismic event, and local railroad crews reported a five-hundred-yard fissure, varying from six inches to thirty-six inches wide and of un-established depth, ten miles northwest of the town.

The last major quake reported in Valentine occurred on January 26, 1954. Though it measured 4.0 on the Richter Scale, no serious damage was reported and no one was hurt.

Today, the repaired Valentine school building plays a big role in the town's Valentine's Day festivities. The handmade postmarks are designed by Valentine ISD teenagers.

FIRST LADY OF SHERIFFS

The first female sheriff in Texas was also the first female sheriff in the United States. Her name was Emma Daugherty Banister.

Emma was born in Forney on October 20, 1871. Following the murder of her father in 1878, she stayed in Forney a few more years and then moved in with an uncle in Goldthwaite to finish school. After receiving her teaching certificate, she taught at Turkey Creek in Mills County and Needmore (now known as Echo) in Coleman County. On September 25, 1894, Emma married former Texas Ranger John R. Banister, a widower and father of six. They settled in Santa Anna, and in 1914, John was elected Coleman County sheriff.

John and Emma moved their nine children to the first floor of the county jail in Coleman. Emma served as office deputy, and John's sixteen-year-old daughter, Leona, served as his driver. John could reportedly ride any horse in the land but showed no interest in mastering the "horseless" carriage.

John was well received and well respected as Coleman County sheriff, bringing standards of competence and courtesy to the position that few sheriffs in any area or era could have achieved, but on August 1, 1918, he suffered a stroke and passed away.

The Coleman County commissioners convened a special session and discussed the possibilities for filling the sheriff's vacancy. Since the next round of county elections was just a few months away, the commissioners

were disinclined to call a special election. At first, they considered appointing Leona, presumably because she'd spent more time in the field with her father and Emma had her hands full with the office secretary responsibilities and single parenthood. In the end, the commissioners chose Emma because they were reticent about Leona's youth and decided Emma's proficiency in the office side of the job would aid in her efforts as sheriff—especially with Leona as her right-hand man or, in this case, woman.

Emma accepted the appointment, and newspapers from New York to California sensationalized the precedent, portraying her as a fearless six-shooter-strapping matron whom troublemakers should be wary of—but the truth couldn't have been more different.

Like her husband, the new Sheriff Banister was courteous and unassuming, a steady hand and stalwart professional. She avoided the sudden press and refused photo requests because she had no interest in publicity. She downplayed the importance of her appointment, remarking that "with the country at war, administering the office will not be difficult at all."

Emma directed deputies, processed prisoners, addressed correspondences, kept the office and jail records, organized jail meals and managed her household. Leona transported deputies around the county to answer calls and serve warrants, summons, etc.

Emma served the final three months of her husband's term effectively but refused to accept the county commissioners' nomination in the next election. As was her habit, she vacated the Coleman County Jail and sheriff's offices quietly and moved her children back to the Banister family farm in Santa Anna.

In her later years, Emma never sought credit or recognition for her short season behind the badge, and the eventual oil boom allowed her to live comfortably and dabble in real estate. Before her death at Brownwood Memorial Hospital on June 4, 1956, she donated a sizable collection of Indian artifacts and mementos from her husband's law enforcement career to the Fort Concho National Historic Landmark museum in San Angelo. She is buried at the Santa Anna Cemetery, and a historical marker commemorating her life was placed there in 1986.

"CIVILIZATION SEEMINGLY A FAILURE IN TEXAS"

The population of Paris, Texas, in the 1890s was close to ten thousand. It was a big town but not so big that folks in the know weren't unaware of the troublesome sorts.

Henry Smith, for instance, routinely had brushes with the law when he drank. Henry Vance, for another example, was a representative of the law who had a penchant for beating prisoners while they were in custody.

Sometime around late 1892 or early 1893, Smith's vice and Vance's penchant planted the seeds for a horrifying murder and gruesome lynching. Vance beat, bullied or otherwise assaulted Smith, but Vance was a white policeman and Smith was a black man. Smith had no official recourse but, after Vance's brutality, apparently devised a terrible plan for vengeance.

On Wednesday, January 24, 1893, Smith grabbed Vance's three-and-a-half-year-old daughter, Myrtle, and allegedly raped and murdered her. They found her body on the outskirts of town the next day, virtually brutalized beyond recognition and covered with brush and leaves.

Strangely enough, the mayor of Paris himself, Alexander Cate, claimed to have seen Smith carrying Myrtle past city hall on the day of her disappearance. The fact that a black man carrying a young white girl down

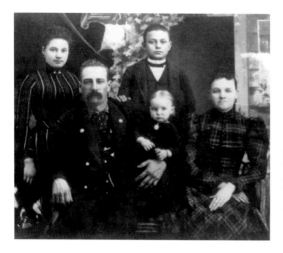

The Vance family. Henry Vance is seated (second from left), with Myrtle under his arm and at his side. Myrtle's twelve-year-old brother is standing behind her. *Courtesy of United States Library of Congress.*

a Texas street in broad daylight in 1893 didn't arouse a sense of misgiving or urgency is suspicious to say the least, but it was the type of evidence that composed a guilty verdict in those days, and by Friday, January 27, the entire community was searching for Smith.

For two days, they combed every acre of northeast Texas with no luck, and then someone remembered Smith mentioning that he had come from the Hope area of Arkansas. A Paris search party boarded a train to Hope and captured Smith twenty miles north of the town on January 31.

Smith and the search party caught the next train back to Paris, and during the trip, Smith was interrogated. According to reports, he initially denied everything, but when his underclothes were examined, investigators discovered they were torn and splattered with blood. Smith supposedly confessed, admitting that he had approached Myrtle with ill intent because her father had beaten him. He said that after he killed the girl, he slept (or, it should be noted, passed out, because he was intoxicated) near her body and returned home the following morning. He claimed he had his wife fix him breakfast and, when she asked about the missing white girl, denied having seen her. He then disappeared and wasn't heard from again until he was apprehended in Arkansas.

After Smith's confession, his captors informed him that his punishment would be to die by torture. Smith became frantic and requested to be shot instead. He begged for protection; he begged for the mercy of a bullet. His panic was palpable, but his captors were unsympathetic.

The murder of Myrtle Vance was the most heinous atrocity anyone could recall being committed in the region, and public white sentiment was almost unanimous in pronouncing that the perpetrator deserved a punishment

as horrific as the crime. As local columnist Alexander Neville put it, "The people felt a crime that had never been contemplated by the law had been committed and they made a law to fit it as nearly as possible." A ghost writer for the Vance family later echoed Neville's sentiment in *The Facts in the Case of the Horrible Murder of Little Myrtle Vance and Its Fearful Expiation*:

> *The silent trial of Henry Smith had passed in the atmosphere around us and every heart re-echoed the solemn verdict "Justice!" The crime was beyond description in words borne in even our prolific language. Our statute books held, in all their pages of fact and precedent, no law worthy to mete out justice in such a case; and now the morning of February 1st silently revealed the solution of the problem, and all the people responded, "Amen!"*

News of the proposed "fitted" justice spread throughout the state like wildfire, and Governor James Hogg implored Lamar County sheriff D.S. Hammond and county officials to "protect the majesty of law and the honor of Texas" and prevent the lynching.

On February 1, Hammond wired Governor Hogg, noting that "Henry Smith arrived and is in the charge of 5,000 to 10,000 enraged citizens. I am utterly hopeless to protect him."

The Paris that Smith returned to was hellishly festive. Anglo citizens from Dallas, Fort Worth, Sherman, Denison, Bonham, Texarkana and southern Arkansas poured into Paris as rapidly as the supplemented train service could deliver them. Businesses were closed, and one of the execution's chief witnesses, Mayor Cate, gave schoolchildren the day off. Smith's torture was the event of the season.

In preparation for the punitive spectacle, a ten-foot wooden scaffold—with "every appliance necessary" and a post in the middle to serve as a stake—had been built out on the open prairie southeast of the railroad depot. The word "JUSTICE" was painted on a horizontal cross-board beneath the scaffold.

When Smith arrived and saw all the white people waiting for him at the station, he collapsed in a terrified heap and had to be carried to the large flat freight wagon that would take him to the scaffold. But instead of proceeding directly to the scaffold, Smith's captors paraded him through the streets of Paris as if atop a carnival float. Spectators jumped on the wagon and pulled away bits and pieces of his clothing for souvenirs, and Smith cried aloud, again requesting someone to shoot him. The parade wound its way to the scaffold, and the eager throng crowded around for optimal viewing.

Onlookers from all over north Texas gathered in the Paris streets to see Myrtle Vance's murder avenged. *Courtesy of United States Library of Congress.*

A crowd of thousands gleefully witnessed Henry Smith's ghastly "expiation." *Courtesy of United States Library of Congress.*

In grimly intimate, eye-for-an-eye fashion, Smith was joined on the scaffold platform by his tormentor, Henry Vance, Myrtle's twelve-year-old brother and one of Myrtle's uncles. They, in turn, stood with various local politicians and dignitaries who gave speeches and made pronouncements and then left Myrtle's familial avengers on the scaffold for the main event.

Fiery buckets containing preheated irons were placed on the scaffold, and Smith's aberrant death sentence commenced. For fifty minutes, Vance, Myrtle's brother and Myrtle's uncle retrieved red-hot irons from the vats and charred Smith's feet, legs, arms, back and abdomen, eliciting blood-curdling shrieks and groans from the sufferer, which in turn were answered by spirited cheers and encouragement from onlookers.

The smell of burnt flesh and smoke hovered in the air like a pall, but the injured Vance clan wasn't finished. In short, dramatic order, they melted Smith's eyes out of his sockets with red-hot irons and then shoved one hot iron down his throat.

Smith, now a blind, quivering ligament of seared human flesh, was hardly responsive when his executioners heaped cottonseed hulls at his feet and poured kerosene over him. But when the kerosene was lit and the rising fire briefly engulfed him in a cocoon of blue flame, his head rose slowly and what was left of his mouth emitted a pitiful lament. His cry was met by shouts and laughter.

In a shocking twist, the fire burned away Smith's binds, and he slid off the burning scaffold and slipped to the earth. His smoldering body was motionless, but spectators pushed it back into the fire. Miraculously—and surreally—the burning body writhed and squirmed free of the flames once more, only to be re-subjected to the conflagration. Finally, the blaze extinguished Smith's life and ended the execution.

When the fire finally subsided, memento seekers raked the ashes, fighting over teeth and bits of bone. Then, the show was over and the crowd dispersed.

The next day, a headline in the *New York Times* dolefully reported "Another Negro Burned," but the *Boston Post* deemed Smith's execution "White Savagery," charging, "Civilization Seemingly a Failure in Texas" in the subhead.

In a chilling postscript, Smith's well-regarded stepson, William Butler, was reportedly also lynched on February 7 because it was suspected that he had been aware of but not forthcoming enough about his stepfather's location after Myrtle Vance's murder. Butler's hanging was little more than an afterthought in the proceedings, but it seemed to conclude the hideous affair.

Governor Hogg attempted to compel the Texas legislature to enact anti-lynching laws in response to Smith's horrendous execution, but his efforts and entreaties fell on deaf ears.

As late as 1930, columnist Neville was still defending the efficacy of the Smith execution, insisting that it had been a profound deterrent because no other (presumably white) children had been abducted or murdered in the vicinity of Paris since the event.

MISSING FOOTAGE OF THE FIRST SPECIAL EFFECT

American inventor Thomas Edison loved trains. When he received word that a real live locomotive smash-'em-up was about to take place in Texas, he immediately dispatched an assistant named J.W. Rector.

Edison had recently invented a motion picture recording machine known as a Kinetoscope. The smash-'em-up promised to be a spectacular live event, and Edison thought it might make for excellent footage.

The smash-'em-up all started with the fantastical scheme of a railroad passenger agent. His name was William G. Crush, and he worked for the Missouri, Kansas and Texas Railroad, popularly known as the "Katy." The Katy was looking to expand its business in the region, and Crush came up with a blockbuster promotion.

In the early 1890s, the Katy had started replacing its older, thirty-five-ton steam engines with larger sixty-ton engines. There were soon dozens of thirty-five-ton units that the Katy no longer needed. Some were sold to gravel companies, and others wound up in logging camps. There were still several left, and Crush realized he could kill two birds with one stone. He'd requisition two of the old thirty-five-ton engines and stage a Katy Railroad version of demolition derby, tentatively designated "The Duel of the Iron Monsters." He

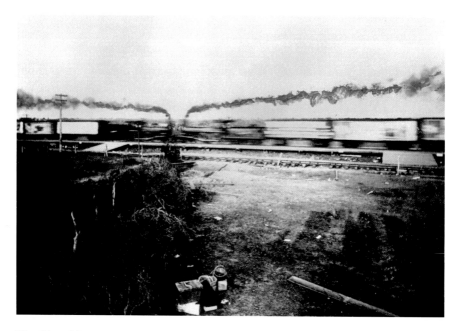

The "Iron Monsters" at the exact moment of impact. *Photo from the Texas Collection, Baylor University.*

pitched the idea to the Katy's top brass, and they signed off on it. Crush went from passenger agent to promoter extraordinaire overnight.

Three twenty-six-year-old Pittsburgh engines with diamond stacks were prepared for the event, one as a spare. Engine 999 was painted green with red trim; Engine 1001 was painted red with green trim. Both locomotives were examined carefully so there would be no hitches on the day of the crash, and then they were coupled with boxcars featuring ads for the Katy, the Ringling Brothers Circus and the Oriental Hotel in Dallas. After they were checked and commissioned, they went out on exhibition tours to market the big event, reportedly posting handbills on every telephone pole along the Katy line, from St. Louis to Galveston.

Meanwhile, Crush did his homework. There was concern that the heavy metal walls of the steam engine pressure tanks would lose their integrity when the locomotives collided. If a boiler-plate was compromised, it would result in a large explosion. Crush consulted several Katy mechanical engineers and was assured that the boilers would remain intact even in the event of a high-speed collision. Crush was bolstered by their confidence and pressed on.

Crush found a spot to stage the event right off one of the Katy mainlines approximately sixteen miles north of Waco. It sat in a field of cotton and

corn crops that was surrounded by three hills. The area formed a gigantic natural amphitheater, and Crush knew it would provide good viewing.

To ensure no stretches of the Katy mainlines would be damaged by the event, Crush had the railroad lay four miles of independent track on the staging grounds. He constructed a grandstand for notable guests and converted a borrowed Ringling Brothers big top into a restaurant headed by the Katy's top chef. He built a special 2,100-foot platform and railway station to handle the anticipated traffic, and the Katy christened the new stop "Crush, Texas."

Anticipating the late-summer Texas heat, Crush had two wells drilled on the site and ran pipes for several hundred spigots. On the day of the event, he brought in eight tank cars containing artesian water and equipped with plenty of tin cups. He also hired a Dallas proprietor to run a dozen lemonade stands in the spectator areas.

Crush created a midway featuring cigar stands, carnival games and stoops for politicians and preachers taking advantage of the massive crowds to speechify and prognosticate. He also set up two telegraph lines and negotiated a franchise for official photos from a Waco photographer named J.C. Deane. To keep the crowds in line, Crush erected a temporary wooden jail and enlisted two hundred special constables.

Admission to "The Duel of the Iron Monsters" was free, and the Katy offered two-dollar tickets for passage to the event from anywhere in Texas. Crush and the event organizers expected twenty to twenty-five thousand people, but on September 15, 1896, forty to fifty thousand people showed up, making the temporary town the second-largest city in the state.

At 5:00 p.m., the viewing areas were packed and the crowd was ready for the show. For dramatic effect, Engines 999 and 1001—both pulling six cars each—touched cow-catchers at the point where Katy engineers had estimated they might meet. Several photographers captured the moment. Then the engineers rolled the trains back to their respective starting positions and awaited the signal.

Crush grandiosely trotted up on a borrowed white horse and stoked the crowd. Then he removed his white hat and ceremoniously tossed it in the air, and the engines started forward. The engineers tied the throttles open and stayed on board for four turns of the drive wheels. Then they and the remaining crew members jumped to safety. The trains raced toward each other, and black smoke poured from their funnels. The excited crowd could hear the popping of the steam a mile away.

The honorary constables had pushed everyone except photographers and local dignitaries hundreds of feet back, and now the spectators stood shoulder

Left: Thomas Edison (circa 1922) loved trains and thought "The Duel of the Iron Monsters" would be a spectacular event to record with his new invention, the Kinetoscope. *Courtesy of the United States Library of Congress.*

Below: The aftermath. After the dead and wounded were attended to, onlookers crowded among the rubble and pilfered the staging area for souvenirs. *Photo from the Texas Collection, Baylor University.*

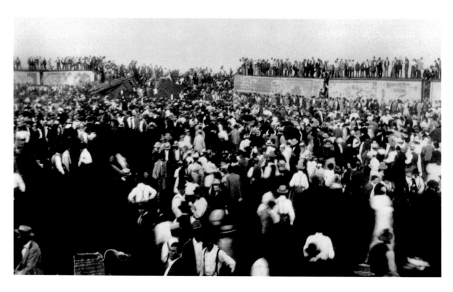

to shoulder across the surrounding pastures. They watched from wagons and trees as the green and red iron monsters approached each other in charges of mutually assured destruction. As one reporter described it, "The rumble of the two trains, faint and far off at first but growing nearer and more distinct with each fleeting second, was like the gathering force of a cyclone."

The iron monsters collided traveling at combined speeds of ninety miles per hour and, for a split second, reared up, their attached boxcars climbing into and over each other. Then the boilers defied the Katy's engineering experts and exploded.

The aftermath was sheer pandemonium. As one witness described it, "There was a swift instance of silence, and then, as if controlled by a single impulse, both boilers exploded simultaneously and the air was filled with flying missiles of iron and steel varying in size from a postage stamp to half of a driving wheel."

A pair of one-ton trucks knocked down a telegraph pole hundreds of yards away. An oak beam felled a mesquite tree that spectators were using for shade. Scalding steam and red-hot iron poured from the sky, and the crowd was packed so tight there was nowhere to run. One Confederate veteran said the smoke, explosions and people falling all around him was more frightening than Pickett's Last Charge at Gettysburg.

Standing between his wife and another woman, Hewitt resident Dewitt Barnes was killed by a hot bolt that went through and through and wounded a woman and child standing behind him. Bremond resident Ernest Darnall was knocked out of a mesquite tree and practically decapitated by a soaring length of chain. A woman named Overstreet was injured by descending projectiles a half mile away. Hundreds were burned by live steam or nicked by shrapnel.

The event photographer, J.C. Deane, lost an eye after a flying bolt (with a washer still attached) lodged in his head. Photographer Louis Bergstom was struck unconscious by a spinning timber plank. Edison's assistant, Rector, hid behind the Kinetoscope. Afterward, he couldn't stop shaking and swore he'd never climb a photographer's stand again.

The beleaguered crowd stood in shock for several moments, and then thousands began sifting through the debris for souvenirs. Hundreds received burns trying to pick up the hot fragments.

Katy representatives were in damage control mode before sundown. They fired Crush and began assessing damages and liabilities.

By sun-up, however, the Katy was a household name; the Crash at Crush dominated world headlines overnight. Crush's "Duel of the Iron Monsters" was an astounding success, and within days, he was rehired.

Thomas Edison's Kinetoscope didn't provide J.W. Rector with much cover. If Rector kept rolling, the Kinetoscope footage of the "Crash at Crush" was lost, destroyed or has yet to be recovered. *Courtesy of the United States Library of Congress.*

The claims of the injured and mortally wounded were quickly processed. Deane received $10,000 and a lifetime railroad pass.

The town of Crush was razed as quickly as it was raised.

The event's progenitor retired from the Katy forty-four years later, keeping a low profile for the rest of his career. He is buried at Calvary Hill Cemetery in Dallas.

The last surviving witness of "The Duel of the Iron Monsters" was reportedly Millie Nemecek of West, and she passed away in 1983.

All that remains of the spectacle, the excitement and the carnage is a historical marker, several fading photographs and the mystery of the missing Kinetoscope footage. If Rector was rolling when the locomotive collision occurred, the film would make the "Duel" one of the earliest events recorded in motion picture history—and the first recorded special effect.

SAN MARCOS TEN

At around 10:00 a.m. on November 13, 1969, a group of students at Southwest Texas State University (now known as Texas State) staged an antiwar protest in front of the Huntington mustang statues just off the main quad. They sat cross-legged and pensive, some wearing black arm bands to mourn the U.S. war dead and some carrying signs. One of the signs said "Vietnam is an Edsel." Another noted "44,000 U.S. Dead, For What?"

News of the My Lai Massacre had just been released the day before. The coming weekend would mark the second national Anti–Vietnam War Moratorium, and over 250,000 people would march on Washington, D.C. Fewer than 75 sat silently around the Huntington mustangs on November 13.

At approximately 10:35 a.m., a university official showed up, surrounded by an entourage of rodeo types and football players. He gave the following ultimatum:

> *Ladies and gentlemen. May I have your attention please? I am Floyd Martine, Dean of Students. In the judgment of the university administration, this assembly is a violation of established university policies as set forth in the Student Handbook. I hereby direct you to leave this area within three minutes. Any student remaining beyond that time will be suspended from school until the fall of 1970.*

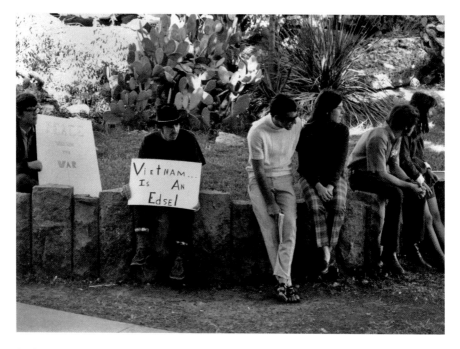

Antiwar protesters gathered at the base of the Huntington mustangs statue at Texas State University on November 13, 1969. *Courtesy of University Archives, Texas State University.*

Martine repeated the statement, gave the group three minutes to clear out and then left.

As campus security officers began roping off the area, most of the demonstrators dispersed; but a handful remained. In the meantime, the crowd outside the rope had increased, bolstered mainly by a "My country right or wrong!" and "Love it or leave it!" contingent. They taunted the remaining antiwar protesters and became threatening. A German instructor subsequently stepped under the rope and joined the protesters.

When Martine returned, he found ten students and the German instructor sitting around the base of the Huntington mustangs. Amidst jeers like "Your three minutes are up" and "Let's drag 'em off," Martine told the protesters they were "through at the university" and began taking names.

The remaining protesters, who came to be known as the San Marcos Ten, were twenty-seven-year-old Vietnam veteran David G. Bayless of Silver City, New Mexico; nineteen-year-old Frances A. Burleson of Houston; twenty-three-year-old Paul S. Cates of San Antonio; nineteen-year-old Arthur A. Henson of Pasadena; twenty-three-year-old Michael S. Holman of Austin; twenty-seven-

year-old David O. McConchie of Wimberly; twenty-four-year-old Murray Rosenwasser of Lockhart; twenty-one-year-old Joseph A. Saranello of Brooklyn, New York; twenty-year-old Sallie A Satagaj of San Antonio; and eighteen-year-old Frances A. Vykoukal of Sealy. They were suspended immediately. No action was taken against Allen Black, the German instructor.

The San Marcos Ten were not alone. On November 13 at Texas Tech University in Lubbock, 10 percent of the student body wore arm bands, but only half of that percentage wore black. The other half wore red, white and blue armbands (distributed by a counter-moratorium group referring to itself as the Silent Majority). At Southern Methodist University in Dallas, a group of antiwar demonstrators delivered speeches and read a list of the 2,200 Texans who had been killed in Vietnam on the steps of Dallas Hall. The SMU protesters also constructed a mock graveyard to commemorate the Texas casualties, and around the rest of the city, the Dallas ISD sent home 20 high school students for wearing black arm bands.

In Beaumont, Lamar Tech (now Lamar University) faculty members held a teach-in, and four African American students from a local high school were arrested for circulating an antiwar newspaper. In Waco, one hundred students attended an antiwar rally in Cameron Park.

The San Marcos Ten hadn't given speeches, passed out literature, read lists of the Texas war dead or built mock graveyards. They had simply taken part in a peaceful demonstration, and it wasn't their first.

The initial national Anti–Vietnam War Moratorium had occurred a month before on October 15. Texas State students had participated in it at the very same location, and there were no repercussions. The first demonstration had been a success and probably gathered much more attention than university officials were comfortable with, especially since Texas State was former President Lyndon Johnson's alma mater.

Regardless of motive, Texas State officials had decided to obstruct the November protest by reducing its visibility as much as possible. Martine restricted protests to a designated "free speech area" away from the central quad and forbid demonstration assemblies prior to 4:00 p.m. on weekdays. Before the November 13 sit-in, protest organizers had spoken with two attorneys recommended by the American Civil Liberties Union (ACLU) to determine their rights. They concluded that they had a First Amendment right to hold another protest in the original location as long as they didn't block quad traffic or create a disturbance.

On the evening of the San Marcos Ten's suspension, hundreds of their classmates and faculty members marched on the Administration Building

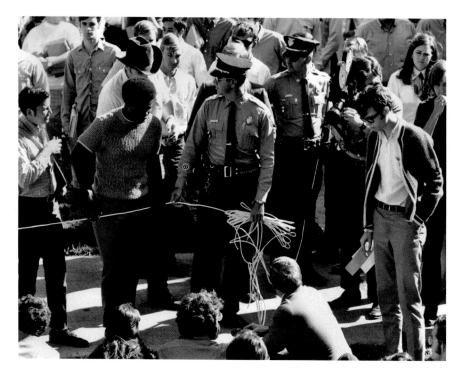

Campus security officers (with the help of a football player) begin roping off the antiwar protesters. *Courtesy of University Archives, Texas State University.*

protesting the Ten's treatment. The next morning, they reappeared, and Texas State president Bill Jones told a group of student representatives that the university "means to hurt no one." "After all," Jones said, "we are here for the same purpose—education."

After their suspension, the San Marcos Ten met with lawyers again and instituted procedures to file a grievance. They fought their dismissal through school channels, presenting their case to the Student-Faculty Board of Review, Jones and the Texas State University System Board of Regents. Their appeals were denied at every level.

The Ten then took their case to federal court. The ACLU filed a $100,000 damage suit against Martine, Jones and Texas State University, maintaining that the university et al had "created a policy which violates the rights of freedom of speech and assembly granted under the First and Fourteenth Amendments to the United States Constitution."

The Ten asked for a temporary restraining order prohibiting suspension prior to a final hearing in court (allowing them to return to classes), a

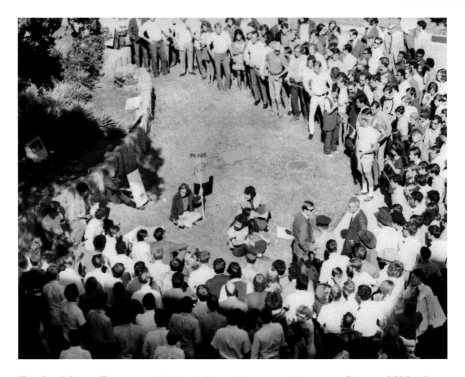

The San Marcos Ten surrounded by their mostly pro-war classmates. *Courtesy of University Archives, Texas State University.*

permanent injunction preventing the university from making notations on their permanent records and a declaratory judgment that the Student Handbook policy dealing with student expression be void because it was characterized by vagueness and over-breadth.

In early December, U.S. Federal Court Western District judge Jack Roberts denied the Ten's appeal for reinstatement but did not rule on the merits of the case, noting that "no party denies that the First Amendment applies with full vigor on the campus, but a university by reasonable regulation, can limit and regulate the exercise of rights granted by the Constitution."

The Ten immediately appealed Roberts's denial to the Fifth U.S. Circuit Court of Appeals in New Orleans and on December 13, the Fifth Circuit temporarily blocked the students' suspension "pending the disposition of this appeal and subject to further orders."

Under the conditions of the injunction, the San Marcos Ten finished the fall semester of 1969 and the spring semester of 1970. But in the

summer of 1970, the Fifth U.S. Circuit Court of Appeals found in favor of Texas State University, ruling that the school had acted within its rights.

The Ten appealed the Fifth U.S. Circuit Court of Appeals decision and then filed a second suit to force Texas State University to grant them credit for the class work they had completed over the 1969–70 school year. The school credit suit landed once again in the chamber of the U.S. Federal Court Western District, and Judge Jack Roberts again ruled against the Ten, stating that he could see no constitutional justification for countermanding the conclusion of the Fifth U.S. Circuit Court of Appeals.

In 1972, the San Marcos Ten appeal was submitted to the United States Supreme Court, but only Justice William Douglas voted to review the case. The U.S. Supreme Court let the lower court's rulings stand without rendering a decision on them.

The San Marcos Ten lost all credits earned during the 1969–70 school year, and their official transcripts read, "The U.S. Supreme Court has ruled for the administration and all credit is denied."

College students all over Texas and around the nation continued to protest the Vietnam War, and the widely condemned Texas State University suspensions of the San Marcos Ten were quickly obscured.

On May 4, 1970—three days after President Richard Nixon referred to antiwar protesters at the nation's colleges and universities as "bums"—the Ohio National Guard engaged a Kent State University demonstration in Kent, Ohio, and shot nine students, killing four and paralyzing one for life.

Eleven days later, in Jackson, Mississippi, city and state police shot fourteen antiwar demonstrators at Jackson State University, killing two.

MEDICINE MOUNDS

When traveling through the northwest Texas prairielands, almost any spike in the horizon is startling. The general topography is placid and lulling, at times even disorienting. When Francisco Vazquez de Coronado was lost here for three weeks in 1541, he admitted being confounded by an indistinct sea of grass.

Now, as then, vertical anomalies are few—especially of the natural variety. But just south of U.S. Highway 287, between the Hardeman County towns of Quanah and Chillicothe, four conical protrusions warrant attention.

Dolomite remnants of the Permian Age (225 to 270 million years ago), they rise 250 to 350 feet skyward, ascending from lowest to highest in a northerly progression. In order from shortest to tallest, they are known as Little Mound, Third Mound, Cedar Mound and Big Mound. And the apex of the Big Mound features a flat cap-rock that protects it from the elements.

For the Comanche Indians, the Medicine Mounds (as they came to be known)—particularly the Big Mound—composed some of the most sacred geography in the plains. There was a gypsum spring at their base, and Big Mound was the staging grounds for rituals, vision quests and the collection of medicinal substances. The earth below it offered up Indian breadroot, gray sage, sumac, snakeweed, wild onions, plums and prickly pear.

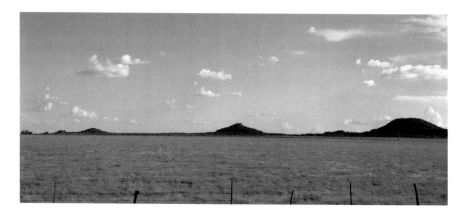

Above: The Medicine Mounds in Hardeman County—(left to right) Little Mound, Third Mound, Cedar Mound and Big Mound—composed some of the most sacred geography in Texas for the Comanche Indians. *Photo by author*.

Left: Quanah Parker was the last leader of the fierce Comanche Quahadi band and visited the Medicine Mounds frequently. *Courtesy of Billy Hathorn*.

An early Comanche legend told the story of a medicine man's daughter who became ill and grew feverish when they passed through the area. The medicine man bade her to rest in his teepee and treated her with every remedial herb and restorative concoction in his repertoire, but to no avail. Her condition deteriorated day after day.

Desperate, the medicine man began to pray and fast and turned to the Big Mound, where a benevolent spirit was believed to inhabit the heights. The supplication inspired him to gather his curatives, transport them to the mound and mix them there. Atop the mound, the spirit could watch over his efforts and infuse his medicine.

When the medicine man returned to his teepee, his daughter's condition had already begun to improve. And when he treated her with his medicine, she quickly recovered. In the days and months and years that followed, the medicine man returned to the mounds at regular intervals to pray to the benevolent spirit and make offerings.

Eventually, other shamans heard of the medicine man's success, and the mounds became a pilgrimage for regional medicine men who sought the heights of the Big Mound to concoct curatives in the presence of the benevolent spirit. Ailing Comanche also visited the mounds to drink from the therapeutic gypsum springs. And it was widely held that the spirit that inhabited the mounds watched over the Comanche bands and guided their arrow shafts on buffalo hunts and in battle.

The last chief of the Comanche, Quanah Parker, returned to the mounds frequently, even after the tribe's acquiescence to reservation life. Some said he sought guidance from the benevolent spirit. Others claimed he just wanted to stay close to the spirits of his kin.

On a bitter cold December morning in 1860, not far from the mounds, Quanah's Anglo mother, Cynthia Ann Parker, wife of Comanche chief Peta Nocona, was seized after her husband's small Comanche band was surprise-attacked at Mule Creek by the U.S. Second Cavalry (under Sergeant John Spangler) and a group of Texas Rangers (under future Texas governor Sul Ross). Cynthia had been kidnapped by the Comanche at the age of nine and, by the time of her "rescue," had fully assimilated and grown into Comanche ways.

Accounts contradict, and it is unclear whether Chief Nocona was present at the Mule Creek Indian Slaughter (which came to be known as the Battle of the Pease River in Anglo circles) or survived to mentor Quanah into manhood. Cynthia was returned to her Anglo family. For the rest of her days, Cynthia rejected the white man's way of life and tried to escape at least once. In 1870, she began refusing to eat and succumbed to influenza.

Quanah (the namesake of aforementioned Quanah, Texas) never lost a battle against the white man, but when the Comanche finally accepted their fate, he shepherded the remnants of his people in their transition to sedentary reservation existence.

In 1911, the year of Quanah's death, Medicine Mound (a small town named after the mounds) was founded just east of its namesakes. In its heyday, the community was home to twenty-two businesses and five hundred citizens. In 1933, a fire burned the town of Medicine Mound to the ground, and it never recovered. Though it's still shown on Texas maps, the last business closed in 1966, and today the population is officially zero.

The Medicine Mounds and the benevolent spirit that reportedly inhabits them saw it all—from Spaniard to Comanche to Texan—and they still watch today. They lie protected in a 6,400-acre property owned by the Summerlee Foundation of Dallas. The foundation allows Comanche descendants to visit and worship on the mounds and shields the sites from commercial and private encroachment.

THEODOSIA

O n New Year's Day 1813, the United States of America awoke to one of the most famous missing persons cases in its history. Theodosia Burr Alston disappeared off the coast of South Carolina and left her family and the nation heartbroken.

Theodosia was the daughter of Aaron Burr, third vice president of the United States (under President Thomas Jefferson) and infamous duel foe (and slayer) of Alexander Hamilton. As her mother died young, Theodosia fulfilled the role of hostess of the Burr estate during her father's political rise and was renowned for her intelligence, beauty and grace.

In 1801, Theodosia married Joseph Alston, a wealthy landowner and governor of South Carolina. In 1802, she bore him a son, whom they named Aaron Burr Alston.

After Theodosia's father's vice presidency, he remained in the public eye, but the gaze became increasingly critical. Charged with murder after his duel with Hamilton, Burr was subsequently acquitted. In 1807, he was charged with treason but, again, acquitted. Unlike many of his friends, Theodosia stood by Burr regardless of accusation or affront. Upon his acquittal of the treason charges, Burr left for Europe, a voluntary exile.

While her father was gone, Theodosia lobbied on his behalf, writing letters and entreating U.S. secretary of state Albert Gallatin and Dolley Madison

to assist her in ensuring a smooth return. An optimal path was secured, and Burr arrived in New York in early 1812. Burr implored Theodosia to visit, but on June 30, 1812, her son, Aaron Jr., died of tropical fever. Theodosia, Alston and Burr were crushed by the loss.

Theodosia's misery almost killed her, and it was six months before she could make the trip to New York to visit Burr. Alston was unable to join her, so Burr asked his old friend Timothy Green to accompany her on the voyage.

On December 31, 1812, Theodosia set sail for New York from Georgetown, South Carolina, aboard a schooner called the *Patriot*. Theodosia, Green and the crew of the *Patriot* were never seen or heard from again. After Theodosia's disappearance, rumors immediately sprang up. The earliest indicated that the *Patriot* was intercepted by pirates or run aground on the shoals around Nags Head, North Carolina.

Alston never fully recovered from the death of his wife and son and passed away in 1815. Burr claimed that Theodosia's death "severed" any connection he had with the human race. Conjecture continued regarding the fate of his daughter for decades, but Burr spurned it all, believing until his death in 1836 that she had perished in a shipwreck.

In 1872, writer Charles Etienne Arthur Gayarre devoted an entire chapter of one of his novels to a confession regarding Theodosia made by the infamous privateer, pirate and Battle of New Orleans hero Dominique Youx (a half brother to Jean and Pierre Lafitte). Youx claimed he had discovered the *Patriot* dismasted off Cape Hatteras, North Carolina, following a storm. He said that after stripping the craft of its valuables, he and his men dispatched the entire crew and made Theodosia walk the plank.

In 1874, the December 31 edition of the *Galveston Daily News* published a letter from Jean Baptiste Callestre (of Calcasieu, Louisiana) that claimed the *Patriot* had been attacked by the pirate brig *Vengeance*, of which he was a crew member. Callestre stated that the entire crew of the *Patriot* was vanquished immediately or thrown overboard for the sharks, except for a woman they found in the main cabin. When the captain of the *Vengeance* made an attempt to subdue her, she struck him over the head with an empty bottle. After the woman was captured, they bound her securely and transferred her to the *Vengeance*. According to Callestre's letter, the pirate brig set a course for Galveston Bay, and the woman, whom they soon discovered to be Theodosia Burr, did not survive the voyage. Callestre indicated that Theodosia was interred on Galveston Island.

In 1886, in the April 30 edition of the *Galveston Daily News*, a Texas veteran identified by the initials W.J.J. recalled Theodosia's "sad fate" in a vein similar to Youx's. His letter claimed that fifty years earlier he had been present at the

Left: Portrait of Theodosia Burr Alston by American painter John Vanderlyn, circa 1802. *Courtesy of the New-York Historical Society.*

Right: Portrait of Aaron Burr by American painter John Vanderlyn, circa 1802. *Courtesy of the New-York Historical Society.*

deathbed confession of an old, emaciated sailor (in Mobile, Alabama) who maintained that he was the last survivor of a "piratical" crew who "fell in" with the *Patriot* off the coast of South Carolina. The old sailor said that after the *Patriot*'s captain and crew were "massacred," Theodosia was blindfolded and forced to walk the plank, finding "a watery sepulcher." According to the account, the confessor "spoke in admiration of her fortitude" and "did not wish to die without confession and full contrition for the part he had taken in the bloody deed."

In 1913, the January 12 edition of the *New York Times* published a 100th anniversary piece on the disappearance of Theodosia. It contained the account of a former pirate named Benjamin Franklin Burdick, who also claimed to have been aboard the pirate ship that captured the *Patriot*. But Burdick said that when Theodosia was discovered, his captain offered her a choice between becoming his consort or death. Theodosia chose death and then nobly and defiantly walked into the ocean.

On August 16, 1925, a *Dallas Morning News* article by Florine Montgomery related the pirate abduction thread but added a new twist. Montgomery noted that rumors had persisted for decades that Theodosia's final resting place was in Texas but suggested she was put there by a Karankawa Indian chief instead of pirates. Montgomery reported that the version she heard indicated that Theodosia had been captured by pirates off Cape Hatteras but that her captor's ship had run afoul in a storm while en route to Galveston, wrecking and drifting derelict into Matagorda Bay. As the story goes, Theodosia, still chained to one of the craft's bulwarks, was the lone survivor of the calamity, and she was rescued and brought ashore by a broken English–speaking Karankawa Indian chief.

According to Montgomery, Theodosia lived just long enough to relate her misfortune to the chief and give him a locket she wore around her neck. Then she died and was laid to rest near the mouth of the San Bernard River. At some point later, white men acquainted with the Karankawa chief spotted the locket around the chief's neck and realized it was inscribed with the name "Theodosia."

Testimony regarding Theodosia's woeful passing had filled the lore of the east Texas coastal region for at least a century before Montgomery reported it in the *News*, but Theodosia's missing persons file simply grew more muddled as time passed. A *Galveston Daily News* piece from March 27, 1910, included Callestre's story in a list of "groundless myths" and claimed the entire account was a "ghost" story full of "fictitious narrative." A theory published in the *San Antonio Light* on February 18, 1945, suggested that Theodosia was spared by Youx and became a captive of the Lafitte brothers, eventually winning Jean Lafitte to the American side and thereby ensuring the American victory in the decisive Battle of New Orleans.

Like most tales, Theodosia's story increased more in richness than clarity as the decades progressed, and today investigators are left to sift through a cacophony of rumor and intrigue.

The mouth of the San Bernard River has shifted drastically over the last two centuries, as have the sands of Galveston Island. It will likely never be known if Theodosia Burr Alston was a New Year's Eve shipwreck casualty, a wretched (or willing) captive of pirates or a pitiful foundling rescued to a Texas shoreline by a Karankawa Indian chief.

BIBLIOGRAPHY

Abilene Daily Reporter (Abilene, TX) 14, no. 322, ed. 1, Sunday, July 31, 1910; digital images, (texashistory.unt.edu/ark:/67531/metapth315893), University of North Texas Libraries, Portal to Texas History, texashistory. unt.edu; crediting Abilene Public Library, Abilene, Texas.

Abilene Reporter-News. "Japanese Balloon Bomb Kills Six, War Department Reveals." June 1, 1945, 2.

————. "Metal from 1897 'Spaceship' Crash 'Puzzling.'" May 31, 1973.

————. "'San Marcos 10' Restraining Order Denied by Judge." December 5, 1969.

Allen, Henry Easton. "The Parilla Expedition to the Red River in 1759." *Southwestern Historical Quarterly* 43, no. 1 (July 1939): 53–71.

Alto Herald. "Seven Men Indicted." 10, no. 38, August 25, 1910.

Alton Daily Telegraph. "Burned at the Stake: Horrible Fate Meted Out to a Negro Villain." February 2, 1893.

Altoona Mirror (Altoona, PA). "Woman, 91, Remembers Airship Crash." May 31, 1973.

Amarillo Globe-Times. "Medicine Mounds 'Power' Described." April 30, 1968, 15.

Austin Weekly Statesman. "The Bean Case." 17, no. 46, ed. 1, September 27, 1888.

Barkley, Roy R., and Mark Odintz, eds. *The Portable Handbook of Texas*. Austin: Texas State Historical Association, 2000.

Bartlett Tribune and News. "Jap Balloons Turn West Wild Again." 58, no. 43, ed. 1, July 20, 1945.

Baytown Sun. "State to Get Prehistoric Indian Village." February 12, 1975, 5C.

Bean et al v. Dove et al (Civil Appeals, Fifth District, October 31. 1903). *Texas Court Reporter*, August 3, 1903–July 21, 1904, vol. 8.

Big Spring Daily Herald. "'San Marcos 10' Lawyer Will Appeal." January 12, 1971.

Blodgett, Dorothy, Terrell Blodgett and David L. Scott. *The Land, the Law and the Lord: The Life of Pat Neff.* Austin, TX: Home Place Publishers, 2007.

Boston Post. "White Savagery: Civilization Seemingly a Failure in Texas." February 2, 1893, 1.

Bourgeois, Paul. "Thirty Years Ago, a Strange Whatever Terrorized Lake Worth." *Fort Worth Star-Telegram*, July 1999.

Bronte Enterprise. "Close Friend Dies." 42, no. 6, February 11, 1960.

Brownsville Herald. "Will Disband Company of Rangers." 25, no. 154, December 31, 1918, 1.

Bruce, Leona. *Four Years in the Coleman Jail: Daughter of Two Sheriffs.* Austin, TX: Eakin Publications, 1982.

Busby, Michael. *Solving the 1897 Airship Mystery.* New Orleans: Pelican Publishing, 2004.

Clarke, Sallie Ann. *The Lake Worth Monster of Greer Island.* N.p.: self-published, 1969.

Clifton Record. "Freak Heat Wave Hits Lake Whitney." 66, no. 21, June 17, 1960.

Commerce Journal. "East Texas Race Riot: Several Are Killed." August 5, 1910.

Considine, Bob. "Japan's Balloon Barrage Strangest Weapon of War." *Cedar Rapids Gazette*, May 19, 1945, 20C.

CorpusChristiCaller.com. "Crime and Punishment: The Burning of Henry Smith." April 18, 2012.

Corsicana Semi-Weekly Light. "Reconstruct Deaths of College Students." February 9, 1960.

Cotner, Robert. *James Hogg: A Biography.* Austin, TX: University of Austin Press, 1959.

Cousins, Rick. "Before Roswell, There Was Aurora." *Galveston Daily News*, October 29, 2006, D1–2.

Daily Courier (Connellsville, PA). "Not Race War; Just Slaughter." August 1, 1910.

Daily Times-News (Burlington, NC). "Jap Secret Weapon Flop Is Reported." February 9, 1946, 1.

Dallas Morning News. "The Air Ship Again." April 15, 1897.

———. "As to the Tom Bean Estate." August 5, 1897.

———. "A Bank Cashier Sees It." April 19, 1897.

———. "The Bean Estate: A Man Present to Swear Deceased Was Named Saunders and Not Bean." February 21, 1888.

———. "The Bean Estate Contest." September 27, 1888.

———. "Bean Will Contest Case." September 23, 1888.

———. "Caddo Trace Oldest Highway in Texas." June 8, 1924.

———. "California Man Asks About Tom Bean Case." December 20, 1920.

———. "Court Act Reinstates 10 Suspended Students at SWTSU." December 14, 1969.

———. "Dallas Youth, Two Friends Found Dead." February 8, 1960.

———. "Denison Man's Find: He Sees a Brilliantly Illumined Air Ship Sailing Northward." April 6, 1897, 4.

———. "Did Tom Bean Leave a Will?" August 21, 1892.

———. "Earth Tremors Are Again Felt in Texas Areas." August 19, 1931.

———. "East Texans Rally to Aid of Sufferers." April 26, 1929.

———. "Fish Come from Wells After Earthquake." August 30, 1931.

———. "Grand Jury Takes Up Investigation." August 2, 1910.

———. "The Great Aerial Wanderer." April 18, 1897.

———. "Has 'Monster' of Lake Ended Hibernation?" March 3, 1973.

———. "A Home-Made One." April 19, 1897, 5.

———. "House Members, Tired of Session, Leave for Homes." September 27, 1931.

———. "'Monster' Sighted Around Lake Worth." July 12, 1969.

———. "Mrs. Ward to Qualify for High Court Place." January 6, 1925.

———. "Myrtle Vance Murder." January 31, 1893.

———. "The Mysterious Bean Case." March 27, 1888.

———. "The Mystery of Tom Bean: An Old Acquaintance of the Family." October 2, 1887.

———. "The Mystery of Tom Bean: Mr. Saunders Makes a Statement." September 24, 1887.

———. "Mystery Unsolved as Bodies of 3 Students Are Sent Home." February 9, 1960.

———. "Neff Names Three Texas Women to Function as Special Supreme Court." January 2, 1925.

———. "The Noted Bean Estate." January 24, 1888.

———. "Quake Shakes Several Texas Towns Sunday." August 17, 1931.

———. "Railroad Man Saw It." April 17, 1897, 8.

———. "Search of Canyon Slated Today for 3 Tech Students." February 7, 1960.

———. "Seek to Reopen Tom Bean Case." December 4, 1920.

———. "Seen at Paris." April 16, 1897.

———. "Seen Near Whitney." April 18, 1897.

———. "Seven Indictments in Anderson County." August 18, 1910.

———. "Solving the Bean Mystery." December 1, 1887.

———. "Students Protest in San Marcos." December 18, 1969.

———. "Suit on Tom Bean Estate." December 20, 1907.

———. "Suspensions at SWTSU Protested by Students." November 15, 1969.

———. "Synclinal Basis Fault Shift Blamed for Texas Earthquakes." August 21, 1931.

———. "Team Seeking Parts of UFO." April 1, 1973.

———. "Theories of Cause of Quake Felt in Dallas Are Advanced by Dr. Robert T. Hill." August 18, 1931.

———. "Thousands Saw Crash at Crush." September 6, 1971, 2.

———. "Three Women Served on Court in 1925." June 18, 1982.

———. "Tom Bean, an Eccentric Old Resident of Fannin County, Died Sunday Evening." July 26, 1887.

———. "Tom Bean Case Transferred to Sherman." November 2, 1892.

———. "The Tom Bean Estate." November 29, 1887.

———. "Tom Bean Estate: A New Batch of Kansas Claimants Make Application to Intervene." January 14, 1896.

———. "Tom Bean Estate: Flash Lights on the Status of the Litigation for Millions." June 30, 1892.

———. "Tom Bean Estate: The Maine Heirs' Version of Their Ancestor's Career." June 29, 1892.

———. "Tom Bean Estate Case: Vermont Claimants Given Permission to Intervene." September 17, 1902.

———. "Tom Bean Estate Litigation." June 20, 1900.

———. "To Reopen Tom Bean Case." February 25, 1916.

———. "UFO Bureau to Seek Exhumation of 'Astronaut.'" May 4, 1973.

———. "U.S. Soldiers Chase Bandits into Mexico." December 28, 1917.

———. "Would Reopen Tom Bean Case." July 9, 1916.

Dean, Kenneth. "Burial Mounds Hint of the Lives of East Texas Tribe." *Tyler Morning Telegraph*, April 29, 2010.

Denton Record-Chronicle. "Blinding Panhandle Storm Blamed in Students' Deaths." 57, no. 161, February 8, 1960, 1.

———. "San Marcos 10 Lose First Round." December 5, 1969.

Eckhardt, Charley. "Is Aaron Burr's Daughter Buried in Texas?" *Seguin Gazette-Enterprise,* July 4, 1990, 2.

Elliott, David. "When WWII Bombs Fell on Iowa." *Ames Daily Tribune,* October 19, 1974.

El Paso Herald. "Mexico Says Big Bend Ranchers Have Killed 15 Mex. Laborers." Ed. 1, February 7, 1918.

El Paso Herald Post. "Texas Utopia, Inhabited by 150, Economic Experiment." December 24, 1932, 3.

El Paso Morning Times. "El Emb. Bonillas Protesta Ante El Gobierno Americano." 38, ed. 1, February 8, 1918.

Evans, James R., Jr. "The 1925 All-Female Texas Supreme Court: An Exceptional Legacy." *Heritage Magazine* 16, no. 2 (Spring 1998).

Ex Parte Spurger et al (Court of Criminal Appeals of Texas, May 10, 1911). *Southwestern Reporter* 137, 351–54.

Fort Worth Daily Gazette. "The Bean Estate." 13, no. 173, ed. 1, January 22, 1888.

———. "A Nihilistic Manifesto—Platform of the American Agrarians." 7, no. 307, ed. 1, November 7, 1883.

Fort Worth Gazette. "The Legislature: Bills by Other members to Solve the Fence-Cutting Problem." 8, no. 7, ed. 1, January 9, 1884.

Fort Worth Register. "Oft-Seen Air-Ship: Seen at a Point West on the Texas and Pacific." April 18, 1897.

Fort Worth Star-Telegram. "Earthquakes Rock Central, West Texas." August 17, 1931, 1–2.

———. "Students Found Dead." February 8, 1960, 1.

———. "Whatsit Takes a Night Off." July 13, 1969.

———. "Why Tech Students Died Still Unknown." February 9, 1960.

Galveston Daily News. "The Bean Will at Bonham." January 22, 1888, 5.

———. "Bonham's Great Sensation." September 23, 1887, 1.

———. "Fence-Cutters Work." 42, no. 140, August 9, 1883.

———. "Gardner Delivered Grand Jury Charge." August 2, 1910, 9.

———. "Monster Aerial Navigator." April 17, 1897, 2.

———. "The Mysterious Airship." April 8, 1897.

———. "Theodosia Burr: Her Sad Fate Recalled by a Texas Veteran." April 30, 1886.

———. "Victims of Slocum Mob Were Unarmed." August 1, 1910.

———. "What Happened 30 Years Ago." December 31, 1904.

————. "Whites and Blacks Clash, Eighteen Negroes Killed." July 31, 1910, 1.

Gard, Wayne. "The Fence-Cutters." *Southwestern Historical Quarterly* 51, no. 1 (July 1947): 1–15.

Gilmer Mirror. "Bat Bombers of World War II Almost Take Place of A-Bomb." February 21, 1957, 2.

Givens, Murphy. "Coming of Barbed Wire 'Played Hell With Texas.'" *Corpus Christi Caller-Times*, April 18, 2007.

Glines, C.V. "The Bat Bombers." *Air Force Magazine* 73, no. 10 (October 1990).

Godbey, Ron, and Harold Taft. *Texas Weather*. Oklahoma City: England and May, 1975.

Haile, Bartee. "Barbed Wire Causes West Texas War." *Hays Free Press*, October 10, 2011.

Hammond, C.M. "Kristenstad: A Practical Utopia." *Texas Weekly*, August 29, 1931.

Hardesty, John Pettigrew. *Pioneer Preacher of the Plains*. N.p.: self-published, 1950.

Hatcher, Mattie Austin, trans. *Descriptions of the Tejas or Asinai Indians, 1691–1722*. Reprinted from *Southwestern Historical Quarterly* 30, nos. 3–4, and 31, nos. 1–2.

Holt, R.D. "The Fencecutters' War in Sign and Rhyme." *Dallas Morning News*, October 20, 1929.

Jacobson, Lucy Miller, and Mildred Bloys Nored. *Jeff Davis County, Texas*. Fort Davis, TX, 1993.

James, Marquis. *The Raven: A Biography of Sam Houston*. Austin: University of Texas Press, 1988.

Jaspin, Elliott. "Leave or Die: America's Hidden History of Racial Expulsions." *Austin American-Statesman*, July 9, 2006, A1.

Jone, Jim W. "Ghosts Seen on Greer Island." *Fort Worth Star-Telegram*, July 14, 1969, 8A.

Jones, Nancy Bondurant. "World War II Spawned Some Batty Ideas." *Harrisonburg Daily News-Record*, December 8, 1994, 18.

Keasler, Jack. "Barnstormer's Landing a Bit Smoother." *San Antonio Light*, August 6, 1976, 2A.

————. "'Lindy Quixote' Had Texas Ups, Downs." *San Antonio Light*, May 15, 1977, 5, 12.

————. "The Search for Leon Klink." *Del Rio News Herald*, July 14, 1976, 15.

Kennedy, Bud. "Thirty-Seven Years After Snapping Photo, Bigfoot Talk Gets Man's Goat." *Fort Worth Star-Telegram*, June 6, 2008, B1.

Kerrville Mountain Sun. "Romance and Fame Inevitably Linked with Origination of Texas Names." June 29, 1939, 9.

King, Dick. "Kristenstad Was Co-Op Experiment." *Dallas Morning News,* September 7, 1953.

Knight, Thomas A. "The Burr Mystery, 132 Years Old, Solved?" *San Antonio Light,* February 18, 1945.

Laine, Tanner. "Indian Legend Leaves Label on Mounds." *Lubbock Avalanche-Journal* 51, no. 119, March 19, 1973, 1.

———. "'Medicine Mounds' Offer Nice Glimpse at Area's Past." *Lubbock Avalanche-Journal,* August 17, 2000, 7–27.

Landon, Frances O., and Verdi MacLennan. "Kristenstad, a Novel Colony on the Brazos." *Dallas Morning News,* January 22, 1933.

"Largest Earthquake in Texas." earthquake.usgs.gov/earthquakes/states/events/1931_08_16.php.

Levario, Miguel A. "Cowboys and Bandidos: Authority and Race in West Texas, 1913–1918." *West Texas Historical Association Year Book* 85 (October 2009).

———. "Cuando Vino La Mexicanada: Authority, Race and Conflict in West Texas, 1895–1924." PhD Dissertation, University of Texas at Austin, August 2007.

Lindbergh, Charles. "Lindy Describes Life at Brooks Field." *San Antonio Light,* January 9, 1928, 1B.

———. "We." *San Antonio Light,* January 7, 1928, 11A.

———. "We." *San Antonio Light,* January 8, 1928, 8.

Lubbock Avalanche-Journal. "Catholic Priest at Slaton Is Tarred, Feathered and Lectured Saturday by Irate Citizens." March 3, 1922.

———. "Church Observes 50th Anniversary." August 20, 1972, E9.

Madigan, Tim. "A Century Later, Race Massacre Forgotten by All but a Few." *Fort Worth Star-Telegram,* February 27, 2011.

———. "Story of Slocum Massacre of 1910 'Needs to Be Told.'" *Fort Worth Star-Telegram,* March 6, 2011.

Maguire, Jack. "Aurora's Spacecraft Was Fiction." *Denton Record-Chronicle,* April 4, 1971.

———. "Depression Inspiration Missed Mark." *Denton Record-Chronicle,* September 12, 1971, 4A.

Manitowoc Herald-Times. "Utopia and America." November 22, 1932, 4.

Marrs, Jim. *Alien Agenda.* New York: HarperCollins, 1997.

———. "Fishy Man-Goat Terrifies Couples Parked at Lake Worth." *Fort Worth Star-Telegram,* July 10, 1969.

———. "Police, Residents Observe but Can't Identify Monster." *Fort Worth Star-Telegram*, July 11, 1969.

McConal, Jon. "Wise County Spaceman Legend Lives On." *Fort Worth Star-Telegram*, June 8, 1995, 15.

Meridian Tribune. "Kopperl's Close Encounter With Satan's Storm." May 12, 1983, 1.

Mexia Daily News. "Forecast of Death Made Before Fatal Outing of Youths." February 8, 1960.

Mexia Weekly Herald. "Storm Takes Heavy Tolls in District." 31, no. 17, April 26, 1929.

Michael, Karen Lincoln. "For Land's Sake: American Indians Struggle to Preserve Their Sacred Sites." *Colorado Springs Gazette Telegraph*, June 29, 1996, E1–2.

Montgomery, Florine. "Fortunes Lie Hidden in Texas Hills." *Dallas Morning News*, August 16, 1925.

New Castle News. "Woman Sheriff Can Handle the Lawbreakers." October 11, 1918, 18.

New York Times. "Another Negro Burned." February 2, 1893.

———. "Cavalry to Quell Outbreak in Texas." August 1, 1910

———. "Fence-Cutting in Texas." January 31, 1884.

———. "Mystery of Aaron Burr's Daughter Baffles a Century." January 12, 1913.

———. "Score of Negroes Killed by Whites." July 31, 1910.

———. "Texas's Tichborne Case." September 20, 1888.

———. "A Town in Texas Ponders Mystery of 1897 Spaceman." February 26, 1979.

Nugent, Catharine, ed. *Life Work of Thomas L. Nugent*. Chicago: Laird and Lee, 1896.

Pampa Daily News. "North Texas Community Beats This Depression." 26, no. 250, January 27, 1933.

Pampa News. "Chillicothe Medicine Mounds Symbolize Early Inhabitants." March 6, 1939, 7.

Parade Magazine. "The Bat Bombers." September 6, 1981, 16.

Penal Code of the State of Texas, 1925, 303–4.

Peralta, Eyder. "Here Lies...The Aurora Mystery." *Houston Chronicle*, February 28, 2007, S1–2.

Raines, C.W., ed. *Speeches and State Papers of James Stephen Hogg, Ex-Governor of Texas, with a Sketch of His Life*. Austin, TX: State Printing Company, 1905.

Ramos, Mary G. "The Crash at Crush." *Texas Almanac*, 1993–94.

———. "Texas' All-Woman Supreme Court." *Texas Almanac*, 1998–99.

Ratcliffe, Sam D. "'Escenas de Maritiro': Notes on the Destruction of Mission San Saba." *Southwestern Historical Quarterly* 94, no. 4 (April 1991): 507–34.

Ratliff, Harold V. "Kristenstad Waits for Courts to Write Finis to Dream of Danish Farming Utopia on Brazos." *Galveston Daily News*, October 5, 1937, 7.

———. "Modern Utopia of Kristenstad on Brazos Soon to Be Thing of Past." *Abilene Reporter-News*, October 6, 1937, 5.

———. "Texas Site Where Missouri Lawyer-Farmer Planned a Danish Utopia Reverts to Former Owners, to Become Cattle Ranch." *Abilene Reporter-News*, January 14, 1938, 14.

Robertson, Pauline Durrett, and R.L. Robertson. *Panhandle Pilgrimage: Illustrated Tales Tracing History in the Texas Panhandle*. Amarillo, TX: Paramount Publishing, 1978.

Rusk Cherokean. "Will It Work?" 13, no. 13, October 2, 1931.

San Antonio Express. "Three Texas Tech Youths Die of Exposure on Hike." February 8, 1960, 1.

San Antonio Light. "Board Denies Appeal of Students." November 25, 1969, 7.

———. "Ten Protesting Students Expelled at Southwest." November 14, 1969.

San Saba News. "Rangers Sent to Border." 44, no. 1, January 3, 1918, 1.

Seattle Times. "Saw Wife and Five Children Killed by Jap Balloon Bomb." July 1, 1945.

Semi-Weekly Landmark. "The Story of Aaron Burr's Daughter." October 22, 1895.

Sheboygan Press. "Father Joseph M. Keller of Belgium Dies at Milwaukee." December 18, 1939, 6.

Sherman Daily Democrat. "Demurers Sustained in the Tom Bean Case." 40, no. 116, December 8, 1920.

Simmons, Jean. "Years of Looking Await Visitor in Vast Smithsonian." *Dallas Morning News*, May 21, 1972.

Smith, F. Todd. *The Caddo Indians*. College Station: Texas A&M University Press, 1995.

Sturrock, Peter A. *The UFO Enigma: A New Review of the Physical Evidence*. Japan: Aspect, 2000.

Sun-News (Las Cruces, NM). "Flying Object Reports Started Way Back in '97." August 12, 1966, 16.

Syers, Ed. "Medicine Mounds Rich in Indian Lore." *Corpus Christi Times*, March 5, 1965.

Syracuse Herald. "The Mystery of Theodosia Burr." March 3, 1908.

Texas Almanac, 1992–1993. "The Bombing of Texas."

Tiede, Tom. "Kamakaze Bats Await Nation's Call." *Mt. Vernon Register-News*, August 6, 1977, 4.

Time Magazine. "Americana: Close Encounters of a Kind." March 12, 1979.

Tolbert, Frank X. "Eyewitnesses Tell of Crush's Crash." *Dallas Morning News*, May 5, 1956, C1.

———. "Tolbert's Texas: An 1897 Hoax Still Haunts Aurora Town." *Dallas Morning News*, August 26, 1976, p. 3.

———. "Tolbert's Texas: British Investigated UFO in 1966." *Dallas Morning News*, April 2, 1973.

———. "UFOs Reported Near Aurora." *Dallas Morning News*, December 12, 1977.

"Top Secret WWII Bat and Bird Bomber Program." June 12, 2006. www.historynet.com/top-secret-wwii-bat-and-bird-bomber-program.htm/1.

Van der Borght, Richard. *The Facts in the Case of the Horrible Murder of Little Myrtle Vance and Its Fearful Expiation*. Paris, TX: P.L. James, 1900.

Victoria Advocate. "'Outer Space' Pilot's Grave Marker Stolen." June 15, 1973.

———. "Student Appeal Denied." November 25, 1969, 6A.

Villanueva, James. *Remembering Slaton, Texas*. Charleston, SC: The History Press, 2011

Walker v. Howard et al (Court of Civil Appeals of Texas, May 1, 1895. *Southwestern Reporter* 30 (1895).

Waukesha Freeman. "'Dosia Burr." May 13, 1880.

Wellsville Daily Reporter. "Woman Sheriff Makes Good." October 29, 1918.

Williams, Gail M. "West Texas Vigilantes Attack Priest in 1920." MyPlainview.com, March 30, 2013.

Wisconsin State Journal. "Modern Utopia a Reality in Texas." December 27, 1932, 7.

Wysatta, Jean. "UFO Watchers Go to Aurora and Ask: Who's That 'Little Man' in the Grave?" *Dallas Morning News*, February 11, 1979.

INDEX

ABOUT THE AUTHOR

B orn in Fort Worth and raised in Aledo, E.R. Bills received a degree in journalism from Southwest Texas State University in 1990. When he's not wandering Texas back roads, he does historical, travel and editorial writing for publications around the state.